POSTCARD HISTORY SERIES

Waterbury
1890–1930

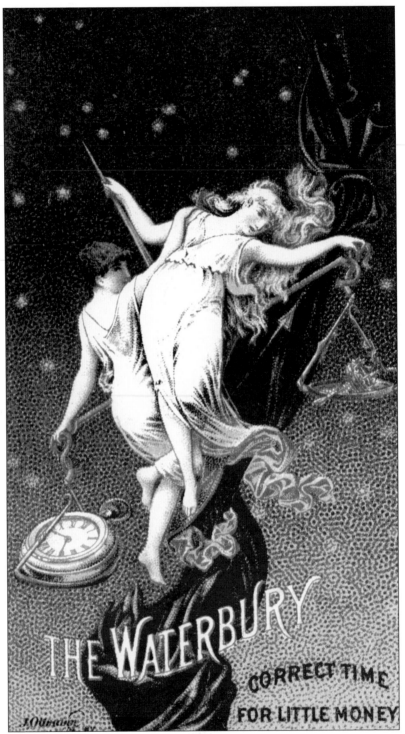

By the 1890s, the name Waterbury was synonymous with timepieces, as indicated by this vintage trade card. But these timepieces, whose key components were made predominantly of brass, owed more to the city of Waterbury than just the name. (TXPO.)

POSTCARD HISTORY SERIES

Waterbury
1890–1930

John Wiehn and Mark Heiss

ARCADIA

First printed in 2003.

Published by Arcadia Publishing,
an imprint of Tempus Publishing Inc.
2A Cumberland Street
Charleston, SC 29401

Printed in Great Britain.

Library of Congress Catalog Card Number: 2003107036

For all general information, contact Arcadia Publishing:
Telephone 843-853-2070
Fax 843-853-0044
E-mail sales@arcadiapublishing.com

For customer service and orders:
Toll-free 1-888-313-2665

Visit us on the Internet at www.arcadiapublishing.com.

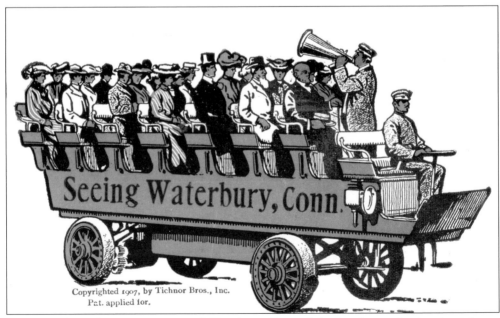

We are ready to depart on our tour of Waterbury. Please sit back, relax, and enjoy the sights.

CONTENTS

ACKNOWLEDGMENTS

The authors would like to thank the following: Beth Heiss, Matthew Heiss, Barbara Heiss, Helen Wiehn, Pam O'Neil, Carl Rosa, Stan Horzepa, Mary White, Mary Witkowski, Ron Gagliardi, Rachael Guest, Debra Gust, Ray Murphy, James Trainor, Charlie Mulholland, Woody Sleiman, Sal Gerosi, Frank and Marguerite Lundin, Bob Rinaldi, Joe Barrett, and the Howard Whittemore Memorial Library in Naugatuck.

Unless otherwise indicated, all images are courtesy John Wiehn.

A key to credited images: The Timexpo Museum, 175 Union Street, Waterbury (TXPO); Lake County (IL) Discovery Museum, Curt Teich Postcard Archives (CTPA); Stan Horzepa (SJH); Barbara L. Heiss (BLH); and Mark D. Heiss (MDH).

This book is dedicated to the memory of John Joseph Barrett (1904–1988), born in the Abrigador section of Waterbury of Irish parents. A graduate of St. Mary's School, he worked for many years at Worden's Dairy, Waterbury Wet Wash, and later, the Bristol Company. His love of Waterbury was an inspiration, without which this book would not have been possible.

INTRODUCTION

The city of Waterbury is an ideal candidate for study through vintage postcards. The years during which Waterbury peaked as a hotbed of manufacturing activity correspond nicely with the peak popularity of sending and collecting postcards. As a result, postcards of Waterbury during the period 1890 to 1930 chronicle Waterbury at its zenith.

The moniker "the Brass City" is no coincidence, as so many of the industries born in Waterbury originated from the brass business. Starting in the late 1700s, button shops sprang up along a number of local swift-moving streams. At first, these buttons were pewter, then later, brass. Out of necessity, these button shops began to roll brass into sheets. As the brass-rolling mills grew, their stockholders spun off new businesses that could utilize their sheet metal as the basic raw material for other products. Soon, in addition to buttons, other hardware was made, including pins, clocks, watches, lamps, appliances, hinges, and screws. The local mills were so successful that by 1900, more than 20 percent of the total brass, bronze, and copper products manufactured in the United States were made in Waterbury.

When viewed today, Waterbury is an enigma. Now with its major businesses in the service sector, abandoned brick factories are slowly being replaced by shopping malls, yet, many vacant factories remain. A train station—arguably the grandest station built by the New York, New Haven & Hartford Railroad and crowned with a clock tower modeled after an Italian landmark—receives only a handful of commuter trains a day. A theater that rivaled any on Broadway for many years teetered between restoration and demolition.

Yet, when viewed through the eyes of the *c.* 1900 postcard photographer, these Waterbury landmarks make perfect sense. The Waterbury Clock Company, the Waterbury Watch Company, Benedict & Burnham, Scovill Manufacturing, Chase Metals, Holmes, Booth & Hayden, Plume and Atwood, Waterbury Button, and American Pin were all at their peak of operation. As both an important freight and passenger hub, it was logical that the New York, New Haven & Hartford Railroad chose Waterbury as the location for its finest railroad station. With civic pride, an impressive array of imposing municipal landmarks, extensive park and recreation facilities, opulent theaters and hotels, Victorian mansions, and impressive churches were constructed, often using renowned architects of the day.

Join us for a peek back in time to the Waterbury of 1890 to 1930. Through postcards, with occasional advertising trade cards and supplemental period images, Waterbury is celebrated for its rich architecture, thriving businesses, and interesting diversions.

—Mark Heiss and John Wiehn

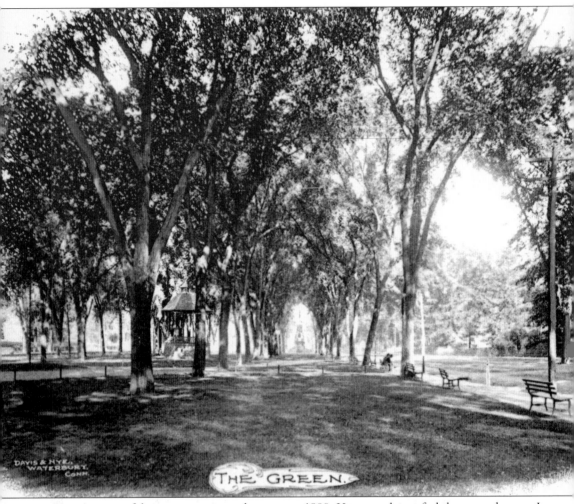

THE GREEN.

Here is a peaceful summer scene on the green *c.* 1900. You can almost feel the warm breeze. In the distance, a Civil War monument seems enshrined under a canopy of elm boughs. Our tour begins here, at the western end of the Waterbury Green.

One

THE GREEN
A STROLL AROUND
THE CENTER SQUARE

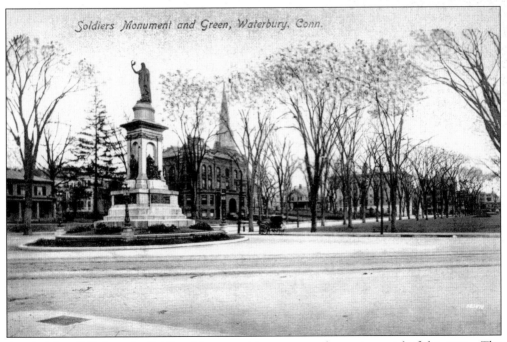

At a height of 48 feet, the Soldiers Monument towers over the western end of the green. The monument, which honors those who fought in the Civil War, was erected in 1884 and dedicated on October 23 of that year. Opposite the green, the YMCA, the steeple of the Congregational church, the Elton Hotel, and the Odd Fellows Hall are all in view. A postcard artist has touched up the leafless elm trees in what is probably a late fall or early winter scene.

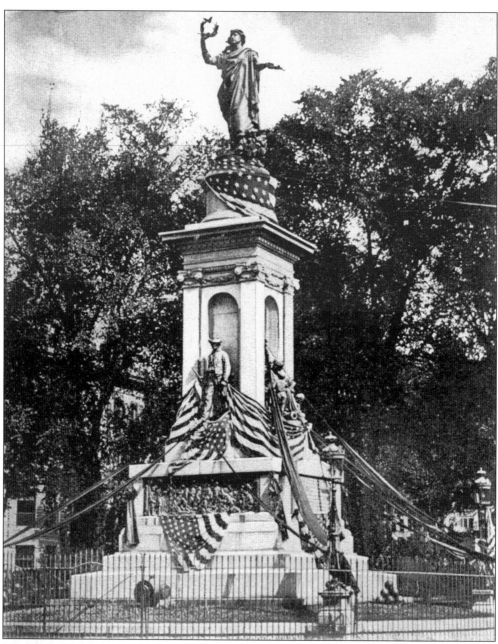

The Soldiers Monument, shown draped in patriotic bunting, is heavily steeped in symbolism. A 10-foot tall bronze woman, Victory, stands atop holding a laurel wreath, her other hand extends an olive branch of peace to the South. Around the midsection of the monument are four bronze statues. Two of these represent workers, a mechanic from the East and a farmer from the West, taking arms to join the war. One bronze statue shows a soldier at the grave of a fallen comrade. The final statue represents emancipation. Below, two bronze panels in bas-relief show a Civil War battle scene and the sea battle between the ironclad ships *Monitor* and *Merrimac*. Engraved in the base of the statue are the stirring words of Waterbury resident, historian, and author Rev. Joseph Anderson.

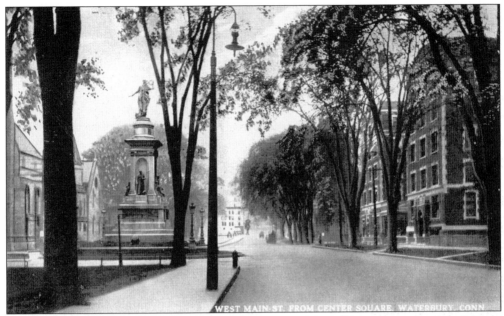

George E. Bissell, a one-time Waterbury resident, designed the Soldiers Monument. The bronzes were cast in Paris while the granite work was from Quincy, Massachusetts. Bissell also designed a number of other Civil War monuments and later exhibited his bronze work at the World's Columbian Exposition in Chicago in 1893. Other examples of Bissell's work can be seen at Riverside Cemetery, including the statue of local Civil War hero Col. John Chatfield.

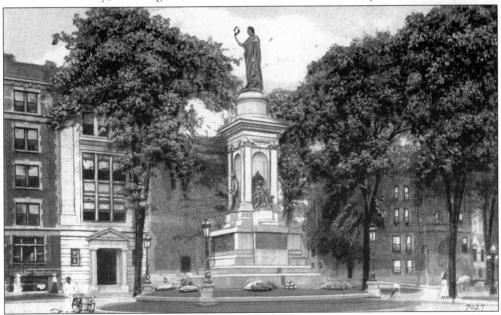

Assembly of the $25,000 Soldiers Monument was conducted day and night for the two weeks prior to the October 23 dedication aided by electric lighting, a novelty at the time. Also seen in this view are the Hitchcock building and Masonic temple on the left, and the YMCA building on the right. In these days of true "horsepower," a street sweeper stands at the ready, with shovel, to quickly remove any pollution problems resulting from horse traffic on West Main Street.

No one is more responsible for the architecture around Waterbury than Wilfred Elizur Griggs. Griggs, a Waterbury native born in 1866, was educated at Yale and Columbia Universities. Griggs designed the Elton Hotel, the Odd Fellows Hall, the Lilley building, the Ried & Hughes building, several Hillside Avenue homes, the Northrup apartment building, and, shown here on the left, the Hitchcock apartment building. On the right is the Masonic temple, which Griggs designed in 1912.

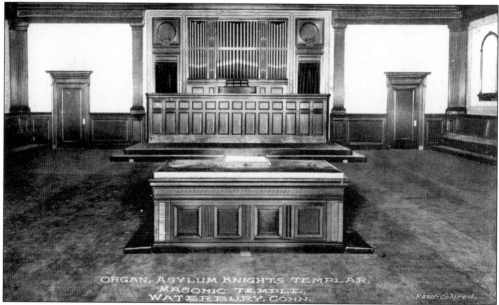

The late 1800s and early 1900s experienced an explosive growth of men's fraternal organizations in the United States. Perhaps the oldest of these organizations is the Freemasons or Masons. The familiar Masons symbol, a compass and square, recalls the tools of the stonemason. The Waterbury Masonic Temple featured a large auditorium on the ground floor. This card shows an upstairs meeting room, referred to here as the Asylum, Knights Templar. Of note is the rack of organ pipes that fill the back wall.

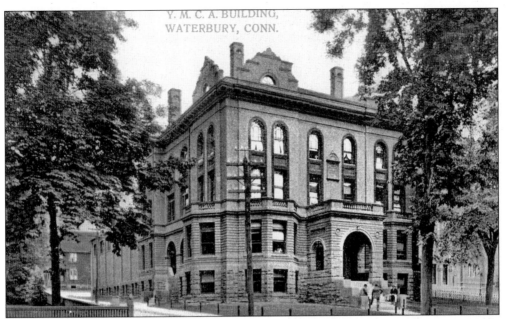

The Young Men's Christian Association is a British import that was created in England by George Williams in 1851 to provide Bible study and prayer, and importantly, a safe environment to the young homeless men of London. The idea caught on and rapidly crossed the Atlantic, resulting in the establishment of the first United States based YMCA in Boston, also in 1851. Incorporated in 1889, the Waterbury YMCA is the oldest YMCA in Connecticut.

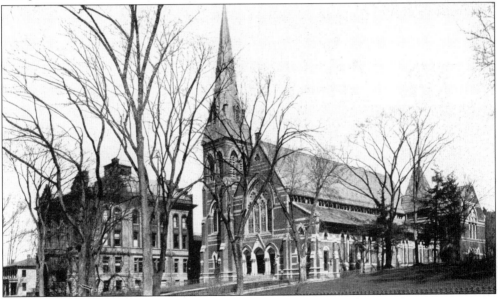

The First Congregational Church was literally the first church in Waterbury, established in 1691 by Rev. Jeremiah Peck. With the first house of worship completed in 1702, Rev. John Southmayd continued Reverend Peck's work in 1705. One notable pastor was Rev. Joseph Anderson who, in addition to serving his congregation for more than 45 years from 1860 to 1905, was a significant contributor to the book *The History of the Town and City of Waterbury*. This building, the fifth incarnation, was completed on March 25, 1895.

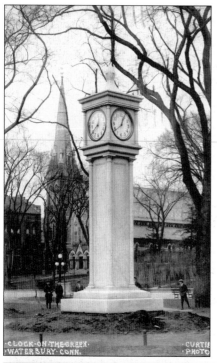

Dedicated on November 25, 1915, the granite clock tower on the green has long been known as Colley's clock. It was through the efforts of Charles Colley, president of the chamber of commerce, that the idea for a clock was promoted and the necessary funds were raised. The design of the case was taken up by Paul Lux, whose Lux Clock Company was a recent addition to the Waterbury family of timepiece manufacturers. However, Seth Thomas, of nearby Thomaston, made the mechanism. This early photograph shows the finished clock prior to the completion of the landscaping.

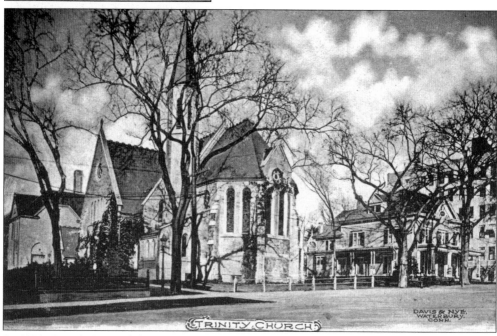

In 1872, St. John's parish began to consider the need to either expand the church or establish another church to support Waterbury's growing Episcopal congregation. When Samuel Hall bequeathed $15,000 to build a church in memory of his wife, a new church became a reality. Trinity Church on Prospect Street held its first services on May 18, 1884. According to *Pape's History of Waterbury and the Naugatuck Valley, Connecticut,* it was built at a cost of $71,829 and constructed of "Plymouth granite with broken surface."

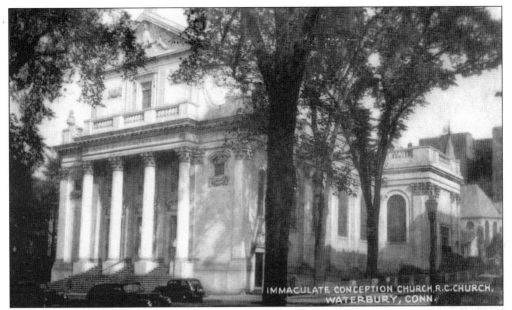

The imposing new Church of the Immaculate Conception opened on the north side of the green in 1928, replacing an earlier structure that sat on East Main Street. Maginnis & Walsh, the foremost Catholic church architects of the period, designed this building in 17th-century Italian Renaissance style. One of their notable designs is the National Shrine of the Immaculate Conception in Washington, D.C. In this view, the Trinity Episcopal Church on Prospect Street can be seen on the right card edge.

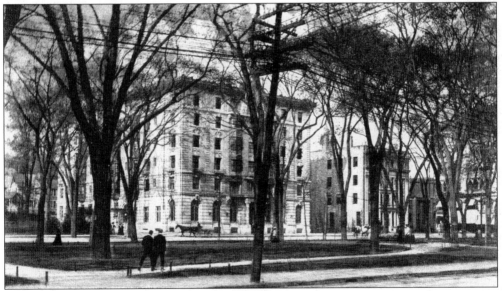

Location is everything. Facing the green was the premium hotel of Waterbury, the Elton, designed by Wilfred Griggs in Second Renaissance Revival style. The Colonial-style Scovill homestead formerly stood on this spot. The Elton opened in 1904 and was considered one of the finest hotels in the East. A sum of $300,000 was raised for the construction, and the list of stockholders read like a who's who of Waterbury businessmen and businesses. Almon C. Judd was a major investor and the first manager.

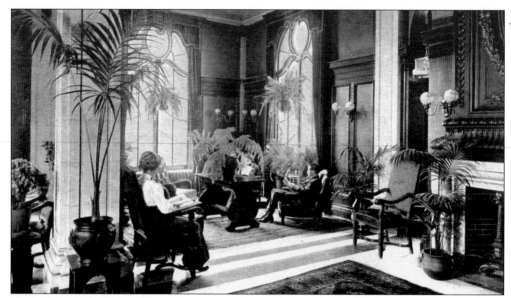

One Elton postcard reads, "The foyer extends across the width of the house, and is 50x100 feet in size; it has a marble floor, and is wainscoted nine feet high with quartered oak. . . This foyer is divided into four imaginary rooms by an arrangement of furniture, making sections for a writing-room, reading-room and two lounging and smoking-rooms." In 1942, then Connecticut resident James Thurber wrote *The Secret Life of Walter Mitty,* which features a Waterbury hotel lobby, often assumed to be here, in the Elton. (SJH.)

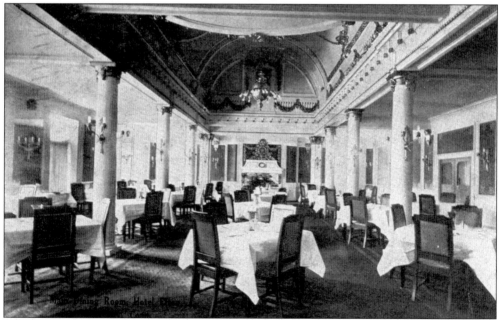

Echoing the French Renaissance was common during the early part of the 20th century. This ornate style, made popular during the reign of Louis XV, was reflected in the Elton's main dining room. White trim, curved details, and gilded accents combined to reflect the age of gaiety and frivolity. Along with a barbershop, custom bar, and billiard room below street level, the Elton investors spared no luxuries.

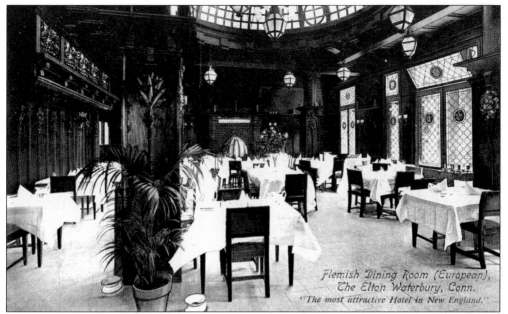

Flemish Dining Room (European),
The Elton Waterbury, Conn.
"The most attractive Hotel in New England."

Though near the main dining room, the Flemish dining room presented a much different look. Here, delicate grapevine and fruit decorations adorned the wainscoting, walls, and columns. One evening in 1920, tenor Enrico Caruso returned to the Elton for dinner after performing at the Auditorium. As Caruso was known to do, he sketched caricatures of some of the Waterbury opera-lovers who dined with him that evening in one of the Elton dining rooms.

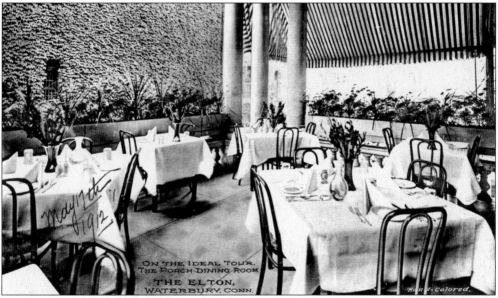

ON THE IDEAL TOUR.
THE PORCH DINING ROOM
THE ELTON,
WATERBURY, CONN.

For dining al fresco, guests could choose the porch dining room shown here. An Elton postcard reads, "In the Elton, mahogany and tapestry are the prevailing notes in furniture and upholstery outside of the public rooms; of the 147 bedrooms and suites on the five upper floors of the hotel, all but three are furnished in plain, rich mahogany pieces, selected from the very best factories in Grand Rapids. . . Three of the finest suites are furnished in a still more costly wood, Circassian Walnut, richly carved."

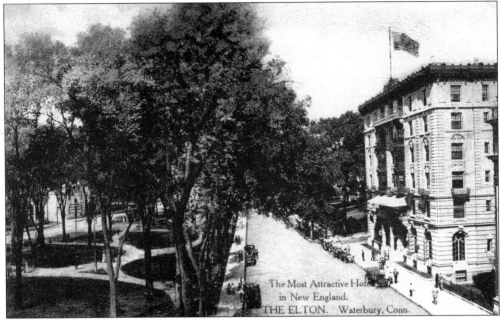

The Most Attractive Hotel
in New England.
THE ELTON. Waterbury, Conn.

This view shows the porch dining room with the awning deployed. An Elton card continues, "Each room has a telephone for house service as well as long distance usage. There are 59 private bathrooms connected with the bedrooms, and 11 public bathrooms. The house is lighted throughout with electricity, generated on the premises." During his presidential election campaign swing in 1960, John F. Kennedy stayed at the Elton and addressed a crowd estimated at 40,000 from the balcony at 3:00 a.m.

City Green, Waterbury, Conn.

For a time, the Waterbury Green sported a traditional New England staple, the gazebo. Summer concerts were regularly held and often attracted large crowds. As a result, the condition of the green began to suffer. In 1902, Mayor Kilduff ordered the gazebo moved to Hamilton Park. This view of the green looking west from its easternmost edge suggests things to come with several prominent "Keep Off The Grass" signs.

18

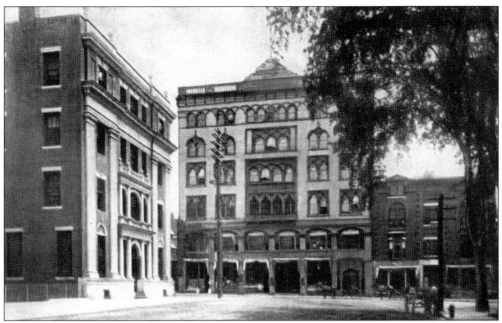

Next to the Elton, on the left edge of this card, is the shared Waterbury Savings and Citizens National Bank building on the corner of West Main and North Main Streets. The Independent Order of Odd Fellows (I.O.O.F.) is another men's fraternal order that took up residence on the Waterbury Green. The duty of the Odd Fellows is "to visit the sick, to relieve the distressed, to bury the dead, and to educate the orphan." Wilfred Griggs designed the Odd Fellows building, shown facing the camera, in 1895.

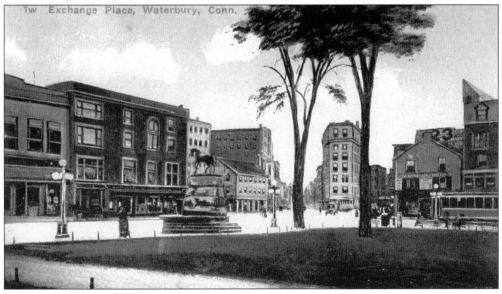

In this view from the Elton, the bronze horse, Knight, stands guard over a deceptively quiet intersection. This intersection, where North, South, East, and West Main Streets and Bank Street all converge, is known as Exchange Place. In addition to roads, all manner of trolleys, cabs, shoppers, and tourists converge here as well. A careful eye will spot a sign for "The Boston Ladies Shoe Parlor" near the right edge of the photograph.

19

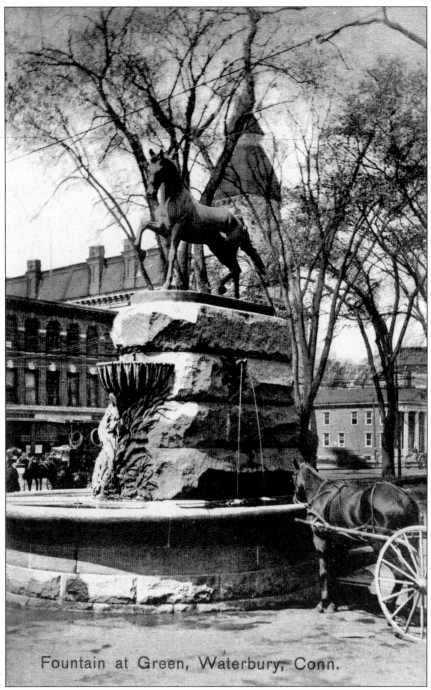

Fountain at Green, Waterbury, Conn.

Dominant on the east end of the green is the Welton Fountain. Caroline J. Welton inherited her father's fortune in 1874, and upon her death in 1884, bequeathed $100,000 to the A.S.P.C.A. and $7,000 for construction of this monument to her beloved black stallion, Knight. Curiously, it was Knight that had dealt the fatal kick that killed her father 10 years earlier. Though her relatives contested the will, after a well-publicized trial the will remained unchanged and the fountain was constructed.

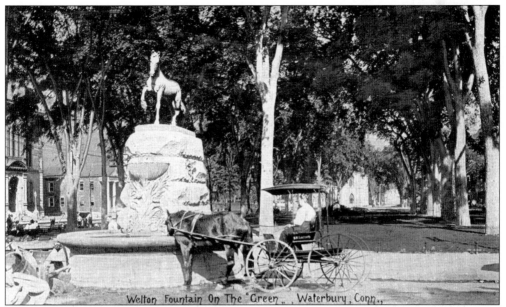

Welton Fountain On The "Green", Waterbury, Conn.,

Dedicated on November 10, 1888, the Welton Fountain is, in reality, an ornate horse-watering trough. The fountain site is at the east end of the green, a common transfer point for passengers traveling by horse-drawn wagon, providing horses a reliable source of fresh water. The artist, Karl Gerhardt, whose benefactor was fellow Hartford resident Mark Twain, was selected to design the fountain. This card shows the fountain being utilized as it was originally intended.

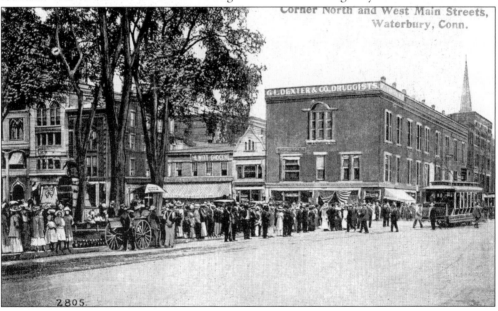

Corner North and West Main Streets, Waterbury, Conn.

The southeast corner of the green appears ready for a Fourth of July parade. G.L. Dexter & Company Druggists is suitably decorated with a draped American flag. On the right edge of the photograph, the steeple of the original Church of the Immaculate Conception on East Main Street is seen. The horse-drawn delivery truck parked under the trees has the name James Dick on the driver's shade umbrella. According to the United Catholic Societies, James Dick manufactured "high grade harnesses" and dealt in "horse goods of every description."

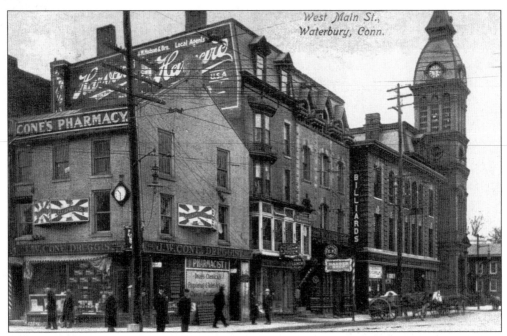

The corner of Exchange Place nearest the green is referred to as "Bauby's Corner," a reference to Bauby's Market that once occupied this site. This photograph, *c.* 1908, is rich in details. Judging by the men's coats and the blanketed horse, this is probably a cold winter morning. A sign in the window of Cone's Pharmacy reads, "Pharmacist: Drugs, Chemicals, Proprietary Goods & Toilet Articles, Choice Confections."

By the 1920s, the horse-watering trough was becoming a relic of the past, as the automobile quickly replaced the horse traffic. For a time, consideration was given to moving the fountain to Library Park near Union Station, where horse teams were still being used for hauling freight, but it never happened. Hereafter, with the exception of rare instances, such as parades, the Welton Fountain took on more of a decorative than utilitarian role.

22

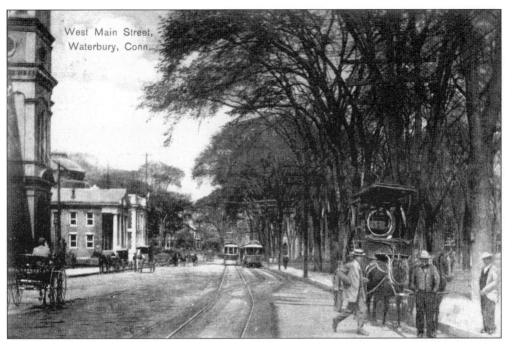

This early view of West Main Street and the green, looking west from Bauby's Corner, dates from *c.* 1900. In addition to the horse-carriage traffic and electrified trolleys, the old city hall, the old Silas Bronson Library, and the Colonial Trust Company Bank buildings are seen on the left.

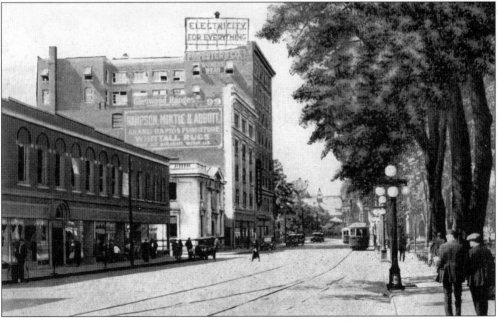

This view of West Main Street from the 1920s shows how quickly and dramatically the area surrounding the green changed. When compared to the previous view, only the Colonial Trust Company Bank building remains. The building housing the Lincoln Store has replaced the old town hall and the Silas Bronson Library, and the Hampson and Lilley buildings now dominate the far end of the green. Atop the Lilley building, a billboard proclaims, "Electricity for Everything!"

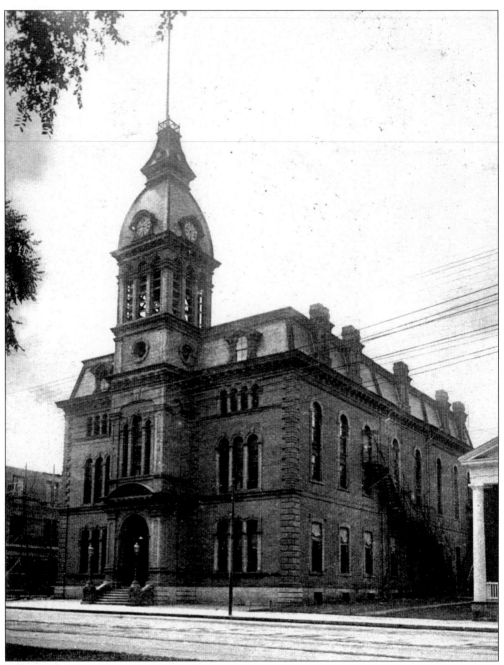

This imposing structure was the original city hall designed by Robert Wakeman Hill and constructed in 1869. By the time this photograph was taken during the first decade of the 1900s, elected officials were already questioning whether the building had outlived its usefulness. When a suspicious fire broke out in April 1912, any concerns regarding the future of the city hall building ceased. Eventually, both the burned-out city hall and the former Silas Bronson Library (on the far right edge of the photograph) were replaced with a shopping and office complex. On the left edge of this photograph, construction is being done on the site of the old Scovill House Hotel, which was destroyed by fire in 1902.

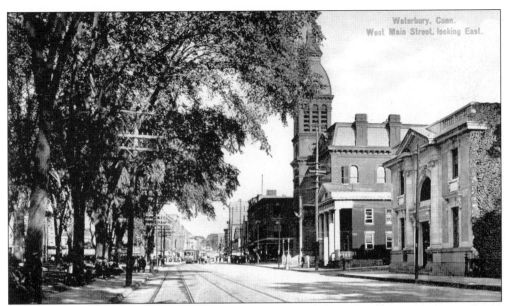

In 1894, electric trolleys were introduced to Waterbury. In addition to intra-city connections, a passenger boarding a trolley in Waterbury could travel to Thomaston, Watertown, Woodbury, Cheshire, Naugatuck, and even New Haven. Here, a distant trolley approaches Exchange Place. On this stretch of track in front of city hall and Colonial Trust Company Bank, a siding allows one trolley to pass another. The trolley system operated for more than 30 years, but finally yielded to busses in 1937.

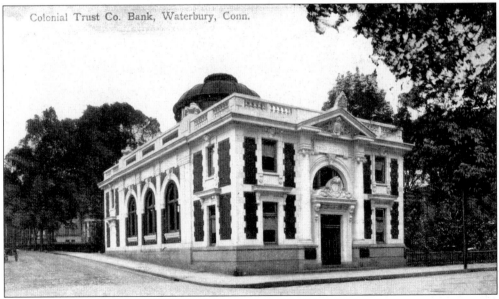

The Colonial Trust Company Bank moved into this new building on West Main Street in 1902 after having occupied a spot on Center Street since 1899. The second president of the bank was John Harris Whittemore, cofounder of the Naugatuck Malleable Iron Company. Whittemore singularly influenced the architecture in downtown Naugatuck, and to a lesser degree, Waterbury, by selecting leading architects, often McKim, Meade & White, to design the buildings that he personally funded.

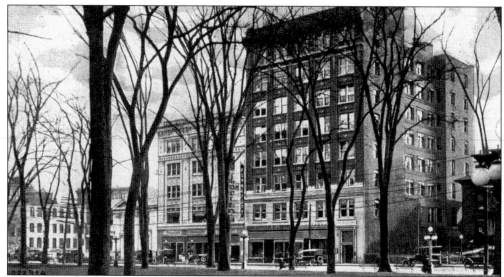

Near the southwestern edge of the green are the Hampson building (on the left), home to Hampson, Mintie & Abbott Furniture, and the Lilley office building (on the right), which was named in honor of the former Connecticut governor and Waterbury native George Lilley. The Lilley building was yet another design by prolific Waterbury architect Wilfred Griggs. Built in 1912 at a cost of $250,000, the Lilley building was the first eight-story steel girder office building in Waterbury.

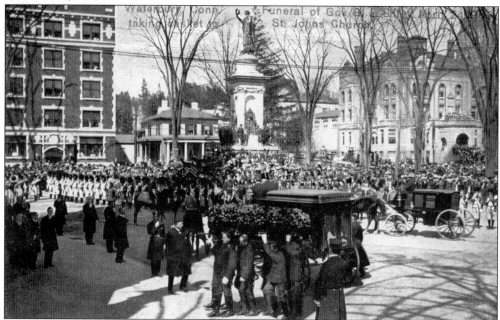

George Leavens Lilley of Waterbury was elected governor of Connecticut in 1909, but he never completed his first term. Over the previous decade, he had held positions in the Connecticut House of Representatives, as well as three terms in the United States Congress. Governor Lilley was the first sitting governor to die in office since the Connecticut state constitution was adopted in 1818. Here, we see the casket being carried into St. John's Church. Notice the observers standing on the Soldiers Monument.

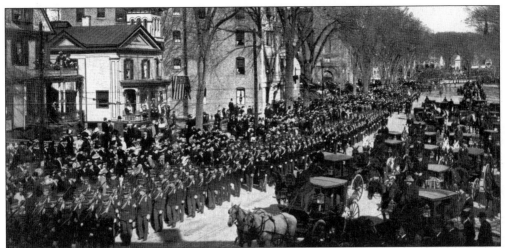

At three months and 15 days, Governor Lilley holds the dubious distinction of having served the shortest term of any governor in Connecticut. He took office on January 5, 1909, and passed away from kidney disease on April 22, 1909, at age 49. At one point, the funeral procession, whose participants numbered more than 2,000, stretched from Union Station to the old city hall via Bank Street. In this view, the funeral procession travels down West Main Street on route to Riverside Cemetery.

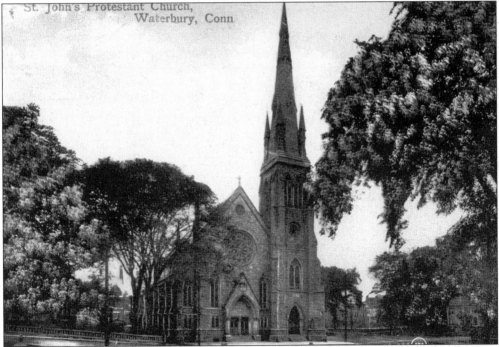

The Episcopal movement, which marked a return to the beliefs and methods of the Church of England, resulted in the establishment in 1737 of St. John's Church in Waterbury. Three different buildings have stood near this spot, starting with a wood-frame structure in 1795, which was expanded in 1839, then replaced by a granite structure in 1848. Although a gale toppled the steeple in 1857, it was a Christmas Eve fire in 1868 that necessitated a new building, seen here, completed June 24, 1873.

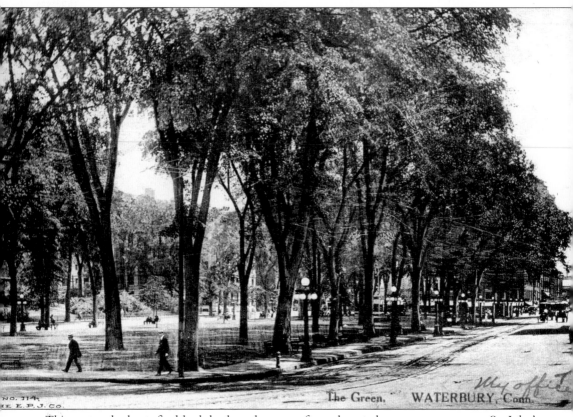

The Green, WATERBURY, Conn.

This postcard takes a final look back at the green from the southwestern corner near St. John's Church and the intersection of Church Street. This photograph is dated *c.* 1920. Someone has penciled an arrow in the direction of the Lilley building pointing toward their office. Most of the elm trees on the green survived an attack by the elm leaf beetle a decade or so earlier, but eventually, they all succumbed to Dutch elm disease, a fungus that ravaged a majority of the elm trees in New England by the 1950s.

Two

BEYOND THE GREEN
EXCHANGE PLACE AND
NEARBY NEIGHBORHOODS

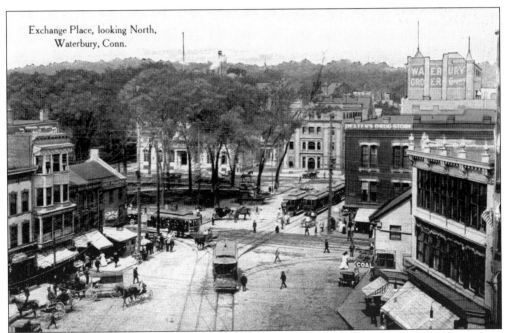

Exchange Place, looking North, Waterbury, Conn.

The crossroads of Waterbury are seen here at a crossroad in time. By *c.* 1910, a well-developed trolley system linked the outskirts of Waterbury and beyond to downtown. Though the horse and wagon still dominated personal transportation, a couple of horseless carriages have already appeared on the scene. It is clear from this photograph, taken from atop the Apothecaries Hall building, why this spot is known as Exchange Place.

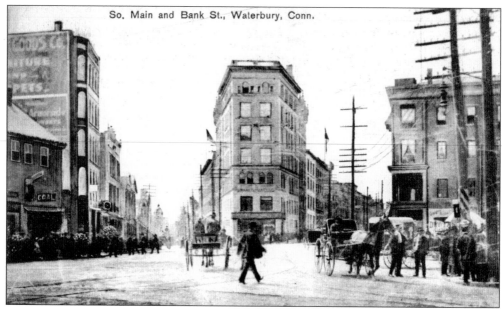

This view shows a typically busy Exchange Place *c.* 1910. At the fork in the road, the landmark flatiron-shaped building is the Apothecaries Hall building. South Main Street begins here and continues straight ahead and on to Naugatuck. Bank Street is seen veering off to the right and continues over the Naugatuck River and into the Brooklyn section of Waterbury. On the left, the wood-frame building contains the Lake, Strobel & Company Jewelers.

APOTHECARIES HALL COMPANY

WHOLESALE AND RETAIL

Druggists

FRESH DRUGS AND MEDICINES
OF THE HIGHEST
PURITY

Prescriptions a Specialty

Painters' Supplies

*The Best there is in PAINT
and EVERYTHING in the
Painters' Supply Line
at a fair price*

APOTHECARIES HALL COMPANY

Wholesale Department	*Retail Department*
Benedist Street	Junction Bank and South Main Streets

WATERBURY, CONNECTICUT

Dr. Gideon Platt established the Apothecaries Hall Company in 1849 to deal in drugs, paints, chemicals, and even fertilizers. This 1907 advertisement for the Apothecaries Hall Company details the variety of product offerings catering to both retail and wholesale customers.

By 1917, the motion picture business was beginning to move away from one-reel vaudeville acts and beginning to move toward feature films, as seen in this advertisement for the Colonial Theater, which was located on South Main Street between Exchange Place and Grand Street. Both Pathe and Fox soon became famous for their newsreels, which provided a glimpse of current events in a way newspapers could not—with moving pictures.

Colonial Theatre

"THE PHOTO PLAY HOUSE OF TEARS AND LAUGHTER"

130 SOUTH MAIN STREET

FEBRUARY, 1917
COMING ATTRACTIONS

Admission 10c.
Afternoon 2 p. m.; Evening 7 p. m.

WILLIAM FOX'S FEATURES
"Little Miss Happiness,"
"Unwelcome Mother"
"Double Life"
"Where Love Leads"
"Fires of Conscience"

WORLD FEATURES
"Little Miss Brown"
"Broadway Trail"
"Maciste" "Edwin Drood"
"Fairy and Waif"

SERIALS
Pathe's Wonder Serial
"Shielding Shadow" every Friday

Comedies Galore

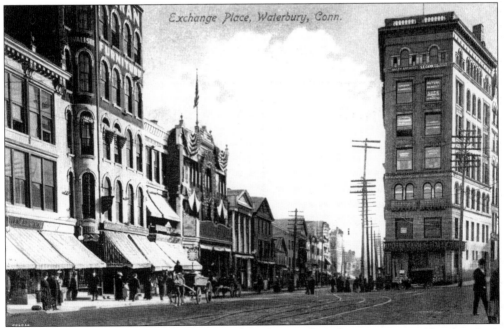

This postcard provides a view of South Main Street as seen from Exchange Place. Theodore Peck designed the Apothecaries Hall building, seen on the right, in 1894. He also designed the Waterbury American building on Grand Street, Waterbury Industrial School on Central Avenue, and Citizens National Bank on the green.

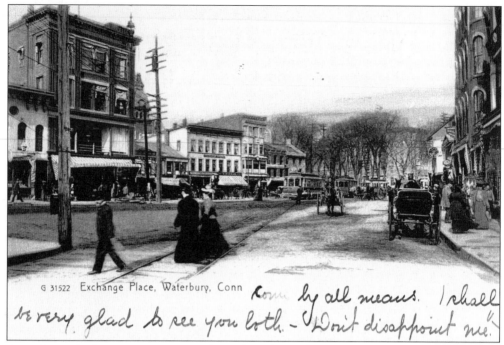

G 31522 Exchange Place, Waterbury, Conn

Come by all means. I shall be very glad to see you both. — Don't disappoint me.

A gentleman is about to step up onto the curb in front of Apothecaries Hall in this northward view of Exchange Place from South Main Street. A major improvement of Exchange Place occurred in 1888, when the dirt surface was paved with granite blocks. For decades, this was the heart of Waterbury's shopping district.

Prior to the explosion in popularity of collecting postcards, advertising trade cards were the rage. This example of a Burgess & Company trade card from the 1890s has a rustic cabin-in-the-woods drawing on the front and this advertisement on the reverse. Of note is the statement that Burgess & Company is next to the post office, which was located on Bank Street at the time. W.F. Brett was the manager. (BLH.)

During the late 1800s, advertising cards were handed out by merchants and often saved in albums by collectors. They typically featured a generic heartwarming or humorous scene on one side with room left for the name and address of the shop. Often, the cards carried an advertisement for the store on the reverse. Godfrey & Company made good use of advertising-card marketing judging by the number and variety of their cards that have survived. Several examples follow. Here is the front of a generic trade card, which has been imprinted with the Godfrey & Company name and address. The back is blank. (BLH.)

You will Find us at 46 Bank St.

BARGAINS!
FOR THE
Working Men,
—AT—
J. A. Godfrey & Co.

Men's Working Pants, $1,00, $1.25, & $1.50
 Warranted not to Rip.
Men's All Wool Pants, $2, $2.50 and $3.00.
 ODD VESTS, $1.00, $1.25 and $1.50.
Men's All Wool Suits, $6.50, $8.50 and $10.
 Well Made, Strong and Serviceable.
Best Blue Overalls, 42c. Jumpers, 38c.
Heavy Twill Cotton Shirts, 38c and 50c.
Dutchess Overalls, best made, 75c
 Warranted not to Rip.
Seamless Hose, 3 pair for 25c
 Shop Aprons, Shop Caps, FREE.

46 Bank Street,
J. A. GODFREY & CO.

This trade card is also from the Godfrey & Company clothing store on Bank Street. It features a generic kitten scene on the front (above), with a simple imprint suggesting the location. The reverse provides a more detailed advertisement (left). Note the enviable pricing. Postcards, which had the benefit of being delivered directly to a customer's home, had effectively replaced trade cards by the turn of the century. (BLH.)

Beginning in 1885, James Hodson operated a café in Exchange Place, and in 1904, he added a restaurant. The Hodson Restaurant was regarded as one of the finest eating establishments in the state. Hodson was a close friend of baseball Hall-of-Famer John McGraw, who was the longtime manager of the New York Giants. The door in the center is for the Exchange Hotel, which later became the Hodson Hotel operated by Hodson with his brother Frank.

Here, we see another Godfrey & Company trade card. In a fascinating coupling, anyone purchasing a boy's suit at this Waterbury store is given a Waterbury watch, built only a short walk down South Main Street, for free. Sadly, it was this tendency of using Waterbury watches as a premium or giveaway that was ultimately one of the contributing factors to the downfall of the Waterbury Watch Company. This practice tended to undermine the entire watch industry while also tarnishing the Waterbury name as it related to watches. (TXPO.)

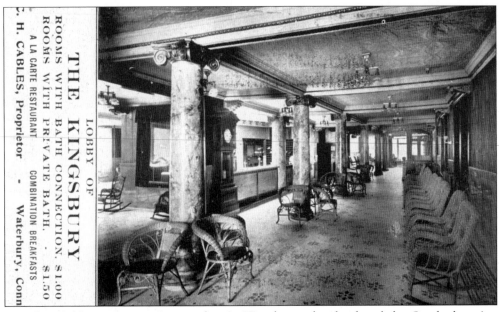

Cornelius Cables was a prominent realtor in Waterbury who developed the Overlook region north of the Hillside district. With the wealth he acquired in housing developments, he purchased several office buildings, an apartment building, and the Kingsbury Hotel on Center Street. The Kingsbury opened on October 25, 1908, and contained 176 rooms, 100 baths, and large "sample rooms." Because Cables was a devout temperance man, the Kingsbury was a dry hotel.

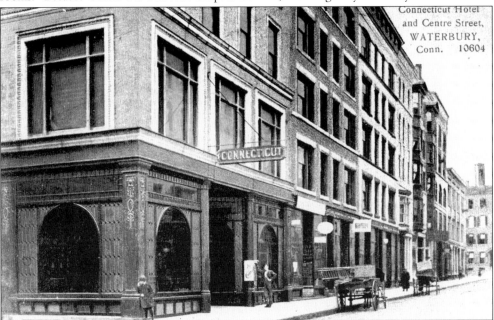

Waterbury's short-lived Connecticut Hotel sat a block off of Bank Street on the corner of Center Street and Franklin Court. Opened in 1904, the Connecticut Hotel was completely destroyed by fire on January 3, 1916. The fire caused one fatality and many injuries, which included broken bones suffered when patrons leaped from the windows into life-saving nets to escape the conflagration. Coverage of the event even warranted a special edition of the *Waterbury Republican*.

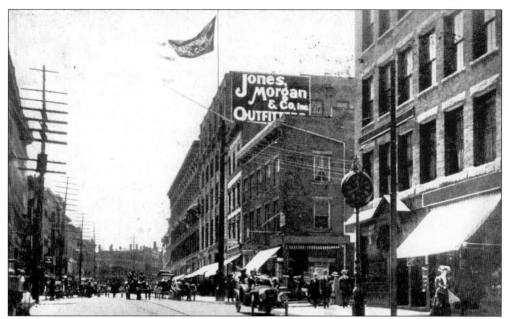

This postcard was specially printed for the Jones, Morgan & Company store on Bank Street, who utilized postcards for advertising purposes, as is seen below. The automobile in the foreground, with right-hand drive and gas headlamps, as well as the abundance of horse-drawn vehicles, places this scene in the beginning of the second decade of the 20th century.

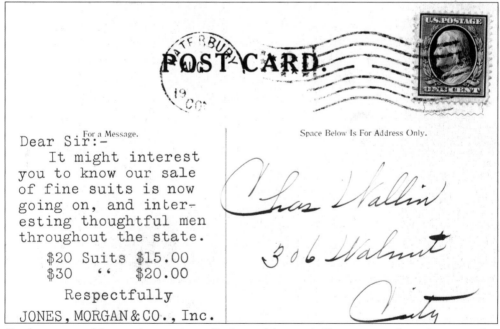

On the reverse of the previous card, a polite Jones, Morgan & Company employee is announcing the latest sale. It is hard to imagine the labor involved in hand typing and addressing cards to everyone on a preferred customer list. But notice how the card has been addressed; there is no need to write "Waterbury" when just a simple "City" will do.

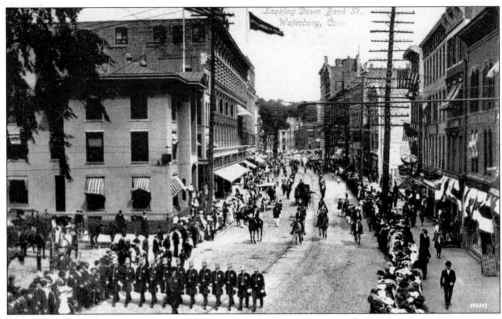

Here, we see Waterbury's finest in full regalia marching in a parade and passing the corner of Bank and Grand Streets. Two large stores anchor this corner, Jones, Morgan & Company, with the flag waving, and Reid & Hughes, with the outstretched awnings. Read & Hughes was later known as the long-running Howland & Hughes Department Store, whose building, another Wilfred Griggs design, was built in 1902.

The Reid & Hughes Dry Goods Co.

WATERBURY, CONN.

47 Separate Departments Under One Roof—The Largest Stocked

DRY GOODS STORE

IN THIS SECTION OF THE STATE.

A Complete line of Dry Goods, Men's and Womens' Wear, Millinery, Cloaks and Suits, Shoes, Carpets and Upholstery, China and House Furnishings.

The Reid & Hughes Dry Goods Co.

122-140 Bank Street - - - - WATERBURY, CONN.

The Reid & Hughes Dry Goods Company began operation in Waterbury in 1890, but was totally destroyed by the devastating fire of 1902. Rebuilt and back in business, this 1907 advertisement clearly suggests the origin of the term "department store."

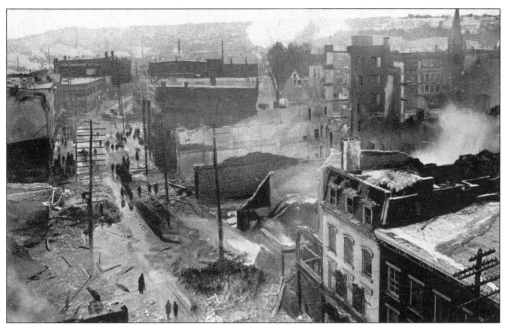

On February 2, 1902, a fire swept through the Waterbury shopping district. The fire was thought to have started in the Reid & Hughes store (center), and quickly spread both east and west. In the end, 30 buildings and more than 100 businesses were destroyed. Initial estimates put the damage at $2,000,000. This still-smoldering view, probably taken from atop Apothecaries Hall, is of Bank Street looking south. The steeple of the Baptist Church on Grand Street can be seen in the distant right.

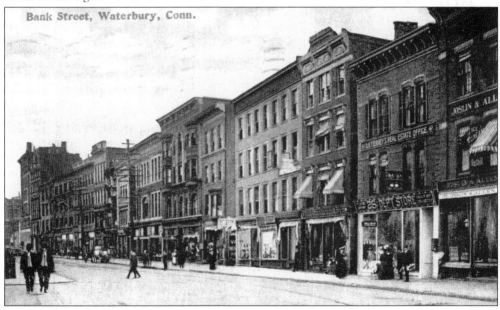

This *c.* 1910 postcard view shows the east side of Bank Street and looks north toward Exchange Place. As seen in the previous photograph, this section was completely leveled by the 1902 fire. Some felt that the city of Waterbury would never recover from the devastation of 1902, but they were quickly proved wrong.

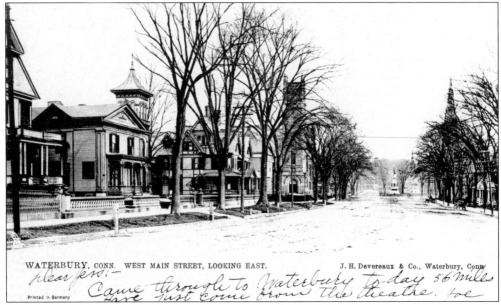

WATERBURY, CONN. WEST MAIN STREET, LOOKING EAST. J. H. Devereaux & Co., Waterbury, Conn.

Came through to Waterbury to-day 56 miles
have just come from the theatre. Joe

This postcard from the first decade of the 1900s provides an idyllic view down the yet-unpaved West Main Street. For the residents of this neighborhood, it was a short walk to the Second Congregational Church, on the left curb, and St. John's Church, on the right. The distant Soldiers Monument marks the start of the green.

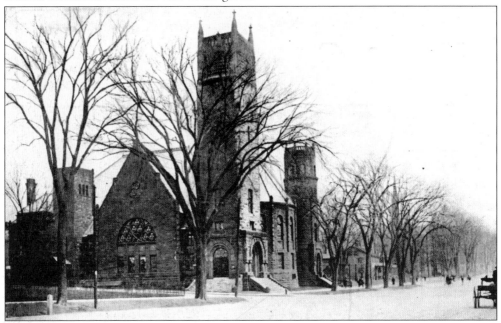

Just as St. John's parish saw the need to expand through creation of another church, the First Congregational Church responded to the growing Waterbury population by creating the Second Congregational Church in 1855, just steps away down West Main Street. Like St. John's, the steeple of the Second Congregational Church tumbled in the same gale-force wind of January 19, 1857. Though it was repaired, sans steeple, a new building, seen here, was later constructed at a cost of $160,000 and dedicated on June 26, 1895.

40

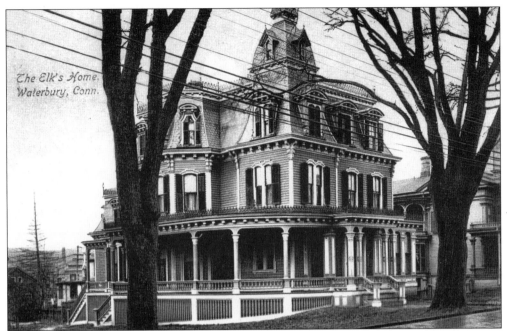

The Benevolent and Protective Order of Elks (B.P.O.E.) is a fraternal organization that was started in 1867 by Charles Vivian and a group of fellow entertainers in New York City, who called themselves the Jolly Corks. In 1868, the group organized as the Elks, dedicated to helping those in need through fundraising activities. The Waterbury Elks organized in 1893, making it the sixth lodge in the state. In 1909, the Elks purchased the Curtis home on West Main Street, shown here, as their lodge.

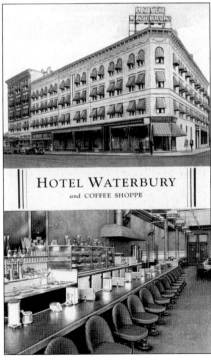

In 1929, Charles Palomba converted the Belvedere apartment building on the corner of West Main and Willow Streets into a 165-room hotel called the Hotel Waterbury. Though the rate of $2 per night seems reasonable by today's standards, the Hotel Waterbury did not survive the Great Depression and closed in 1933. The hotel clerk, Vincent E. Gerardi, later held a similar position for decades at the Elton Hotel.

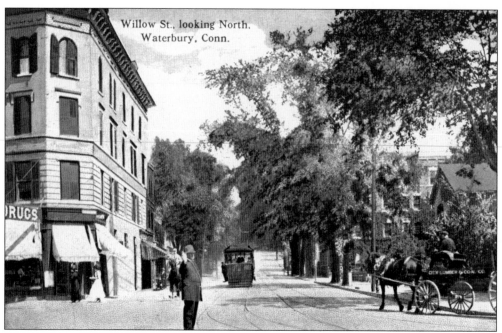

Thankfully, this bustling intersection of West Main and Willow Streets is being kept in check by a Waterbury traffic cop. An electric trolley is approaching after making the rounds of the northern neighborhoods. The delivery wagon is labeled "City Lumber & Coal Co." The Belvedere apartment building on the corner later became home to the Hotel Waterbury.

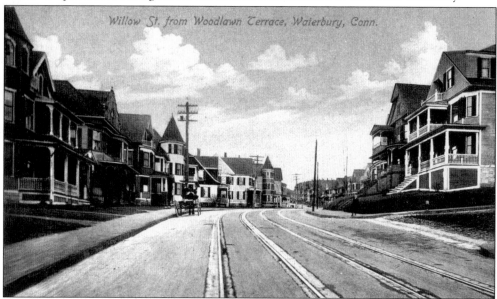

The trolley line circled through the residential sections north of the green via Willow Street, seen here, to Cooke Street, to Chase Avenue, then back down North Main Street. Willow Street is remembered as the birthplace of Rosalind Russell. Born in 1908, Russell was raised in Waterbury and later pursued a career on stage and then in films. She was nominated for Academy Awards for the following films: *My Sister Eileen* (1942), *Sister Kenny* (1946), *Mourning Becomes Electra* (1947), and *Auntie Mame* (1956).

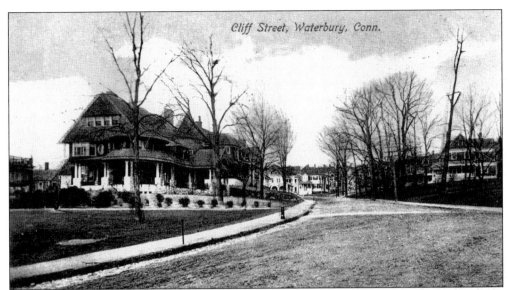

This postcard shows the end of Cliff Street in a view looking north at the intersection of Hillside Avenue. Hillside Avenue and the surrounding streets, particularly the areas east of this photograph, were where Waterbury's elite chose to live. Colonial, Greek, Georgian, Spanish Colonial, and Queen Anne revival architectural styles were all represented. Of particular note was the "stick-style" home of Charles Benedict, president of Benedict & Burnham and brother of founder Aaron Benedict.

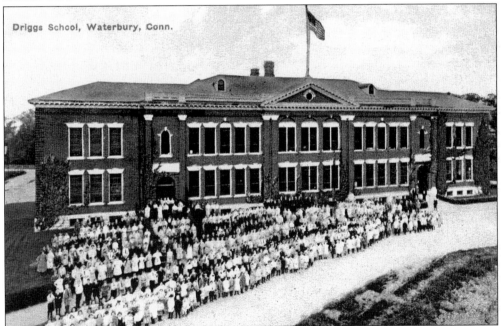

It appears that the entire school has turned out for this postcard photograph of Driggs School. Driggs School, on Woodlawn Terrace, was named after Theodore Ives Driggs. Driggs was president of the American Pin Company in Waterville, head of the Driggs and Smith Music Company, and a member of the Silas Bronson Library's board of agents. The school was built in 1900.

43

Rock Garden, Fulton Park, Waterbury, Conn.

Frederick Law Olmsted (1822–1903) is recognized as the founder of American landscape architecture. Some of his achievements include New York City's Central Park and the Boston park system. Although he retired in 1895, his son Frederick Law Olmsted Jr. and nephew John Charles Olmsted continued the family legacy. The most notable of their Waterbury designs is Fulton Park on Cooke Street. Designed in 1924, the 90-acre park is a memorial to young Waterbury native Lewis Fulton.

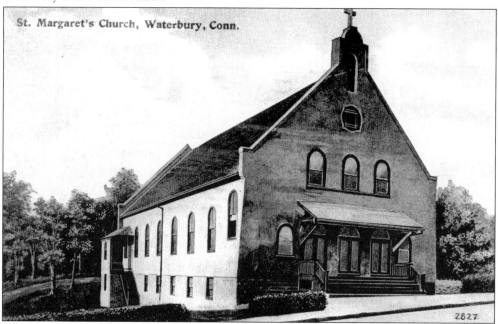

St. Margaret's Church, Waterbury, Conn.

On July 29, 1910, a new Catholic church, St. Margaret's, was added to Waterbury on Willow Street. The first building, seen here, was constructed in 1910, and St. Margaret's Catholic School (no relationship to the nearby St. Margaret's Episcopal School) was added in 1915. The first parish priest was Fr. Edward Brennan. At first, the nuns rented a convent on Chestnut Street. As early as 1917, St. Margaret's began planning a new facility for the corner of Ludlow and Willow Streets.

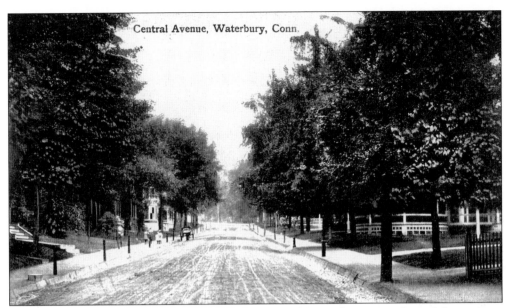

Central Avenue, Waterbury, Conn.

When this photograph was taken in the first decades of the 20th century, Central Avenue was primarily settled with residential homes, with the exception of the Waterbury Industrial School. Eventually, the larger homes on Central Avenue became transformed into commercial properties containing a number of doctor's offices and funeral parlors. Central Avenue continues beyond Grove Street to Hillside Avenue.

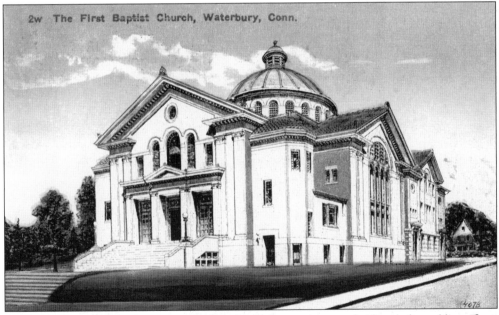

2w The First Baptist Church, Waterbury, Conn.

In addition to hand-tinting, postcard artists often accentuated photos by adding flags, automobiles, and landscaping. Here, a postcard artist has taken a number of liberties with this view of the new First Baptist Church on Grove Street and Central Avenue. This view may have been rendered from early architectural drawings, as the final 1917 structure was quite different in the details and lacked the fanciful dome. This building replaced the original First Baptist Church on Grand Street.

45

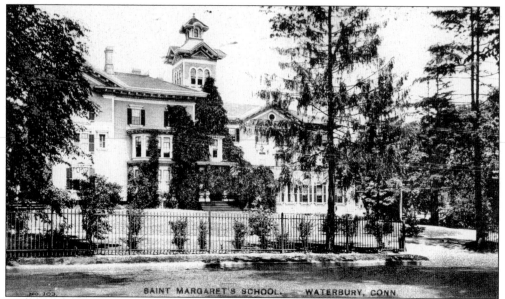

St. Margaret's, an Episcopal diocesan school for girls, was officially chartered in 1875 through the efforts of Rev. Francis Russell of St. John's Church. But the school can be traced back to 1865, when Rev. R.G. Williams created the Collegiate Institute for Young Ladies on the corner of Cooke and Grove Streets. St. Margaret's School was named in honor of Queen Margaret (1045–1093) of Scotland, who is remembered for her efforts in establishing schools and abbeys. She was canonized in 1250.

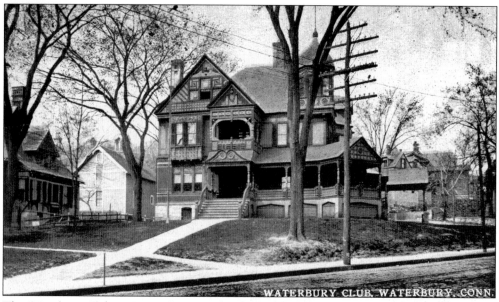

The Waterbury Club was created in 1881 by the business leaders of Waterbury to, according to Pape, "promote social intercourse among men of business." Some of the original 30 members included Augustus Chase, David Plume, William Fulton, James Elton, Julius Bronson, Lewis Platt, and Mark Sperry. Dr. Alfred North leased his home on North Main Street to the Waterbury Club in 1894. The club provided a restaurant downstairs with traditional clubrooms on the second floor. The club later relocated to Holmes Avenue.

46

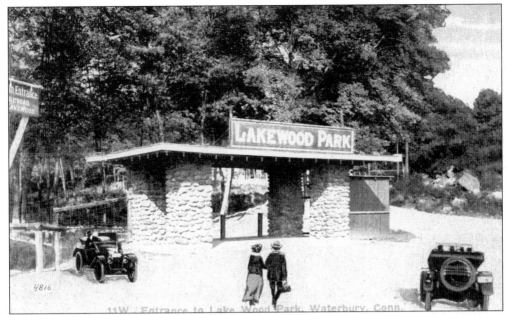

Far up North Main Street near the Wolcott border is Lakewood Park, a popular picnic and swimming area. Lakewood Park began to transform into a full-fledged amusement park *c.* 1914. At its peak, the park boasted a number of rides and attractions, including a three-row carousel and a $45,000 roller coaster, both constructed by the legendary Philadelphia Toboggan Company. Eventually, Lakewood Park returned to its roots and the amusements were removed, except for a few curious remnants. (SJH.)

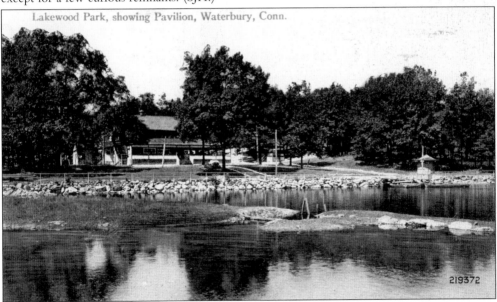

This view of the dance pavilion anticipates things to come. This area would bustle with attractions, including a 2,000-foot L-shaped out-and-back style roller coaster sporting a 63-foot vertical drop and top speed of 35 miles per hour. In the 1930s, the coaster was named Yankee Cannonball after it was moved to Canobie Lake Park in Salem, New Hampshire, where it operates to this day.

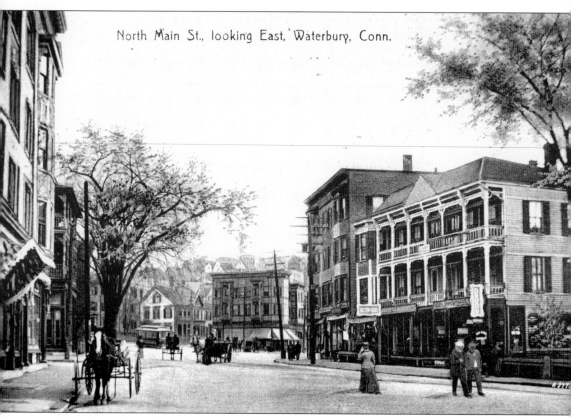

North Main St., looking East, Waterbury, Conn.

Like so many cities, Waterbury is really a collection of neighborhoods. Areas with names like Hopeville, Town Plot, Brooklyn, Long Hill, Bunker Hill, and Mill Plain began as little self-supporting villages within the city of Waterbury. Their collections of small shops, precursors to convenience stores, reduced the need for residents to frequently venture downtown for necessities. For example, here at the corner of North Main and Grove Streets, the small grocery store on the right, next to a small drug store, announces that they sell butter and eggs. In the distance, a trolley arrives at the intersection where North Main Street meets North Elm and Cherry Streets.

Three

BROADWAY MEDLEY
EAST MAIN STREET
TO HAMILTON PARK

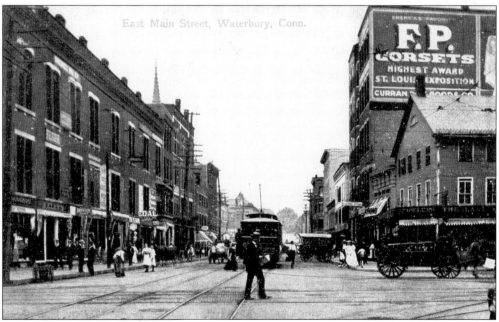

This intersection of trolley tracks denotes the beginning of East Main Street. Nearest the green, East Main contained an assortment of shops, restaurants, offices, and, most notably, a concentration of theaters. It is that concentration of both movie houses and traditional stage theaters that gave East Main Street the nickname "Broadway." Farther out, East Main Street passed behind the extensive Scovill factory, past Hamilton Park, and then on to Cheshire.

Bah! Humbug! Only a "Scrooge" would buy their coffee and tea from a competitor! Or so says this *c.* 1890 advertising card from the Great Atlantic and Pacific Tea Company, the local A & P, on East Main Street. In reality, the rather dated term "humbug," meaning "something intended to deceive," is used quite appropriately in this entertaining advertising copy. The 1890 Waterbury city directory indicates that this A & P employed Mr. Wright and Mr. Weible as the clerks. (BLH.)

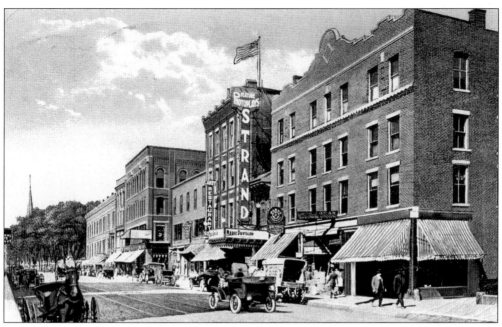

It is the golden age of the silent movie and the Strand movie house on East Main Street is open for business. True to its word, the Stand is offering the top "feature photoplays" of the day. Marie Dressler (whose name is spelled incorrectly on the Strand marquee) was a top box-office draw during the second decade of the 20th century. She came into prominence starring opposite Charlie Chaplin in the 1914 feature *Tillie's Punctured Romance*. (CTPA.)

Mr. Wright and Mr. Weible were formerly clerks at the A & P on East Main Street. Apparently, the coffee and tea business in Waterbury had room to grow, so they started their own venture. This advertisement was printed on the back of an oversized advertising card with a seasonal Easter greetings theme intended to adorn a door, window, or wall. (BLH.)

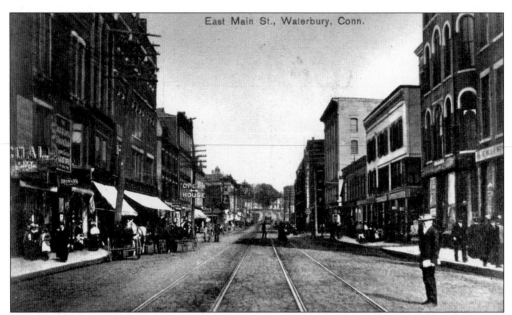

This *c.* 1900 postcard view shows East Main Street and looks east. The sign for the aforementioned Great Atlantic and Pacific Tea Company is just barely visible on the left card edge to the right of the "coal" sign. Farther down the street, a sign points to an opera house down Phoenix Avenue. The opera house is Eugene Jacques's theater.

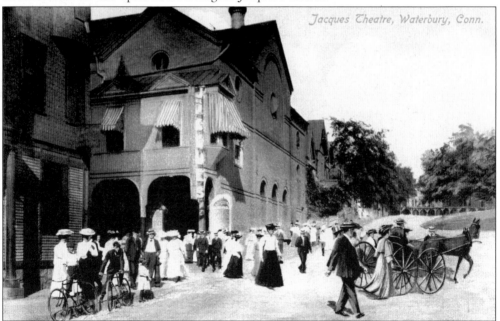

Eugene Leslie Jacques, a Waterbury native, made great strides in attracting professional theater to Waterbury when he opened Jacques Theater in 1893 on Phoenix Avenue. During his first years of operation, Jacques boasted appearances of "all the great artists of the day." But after the 1897 opening of the upscale Poli Theater nearby, a fierce competition erupted. Eventually, the Poli featured the high-class shows, while Jacques settled for melodramas and vaudeville, until motion pictures hastened their decline.

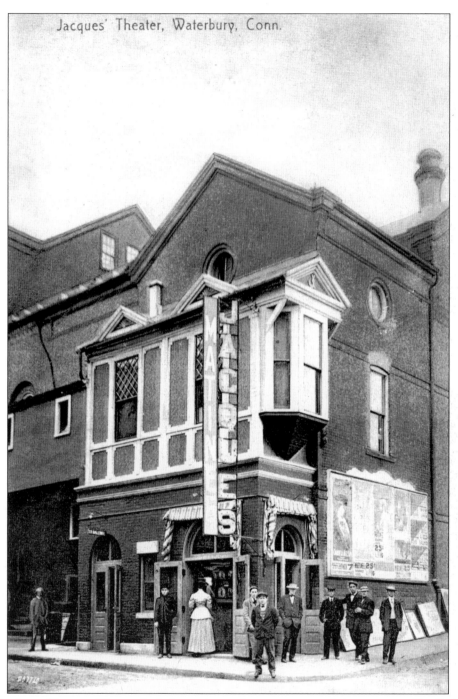

Jacques' Theater, Waterbury, Conn.

This view of Jacques Theater includes an interesting assortment of characters outside. Perhaps these gentlemen are waiting to catch a glimpse of Carlotta Nelson, the performer advertised on the billboard. By mutual arrangement with Sylvester Poli, Eugene Jacques became manager of both the Jacques and Poli Theaters. After Jacques's death in 1905, Poli managed both theaters. Eugene Jacques's daughter, Jean Dixon, achieved a level of celebrity by appearing as a character actress in several films, most notably, *My Man Godfrey* in 1936.

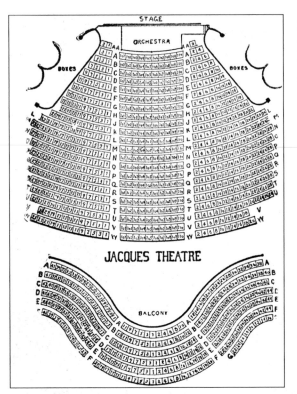

Despite the diminutive exterior appearance of Jacques Theater, this period seating chart shows more than 1,000 seats, complete with private boxes and a balcony.

The old National Guard armory is shown in this view looking north on Phoenix Avenue. Jacques Theater, across Abbott Avenue from the armory, is seen in the distance. The armory was built in 1883, but was eventually replaced with a new National Guard armory on Field Street, behind the new city hall.

In 1857, the Church of the Immaculate Conception on East Main Street became the first building specifically built as a Catholic church in Waterbury. Prior to 1857, masses were held either in a rented building, or after 1847, in the former St. John's Church building, which had been moved to a location near this spot. Reverend Mulcahy was influential in establishing St. Mary's School and Convent. Later, Monsignor Slocum helped to establish St. Mary's Hospital nearby. (BLH.)

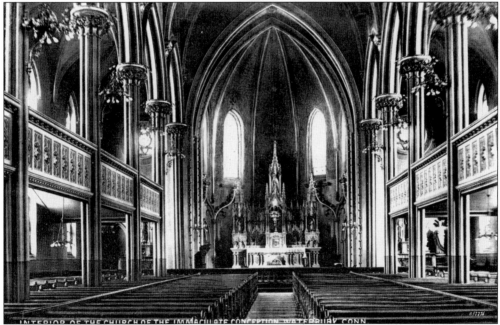

The interior of the Church of the Immaculate Conception is shown on this card. It was here that Fr. Michael McGivney said his first mass after being ordained. In New Haven, Father McGivney later created the Knights of Columbus. One of the largest funerals in the history of Waterbury was held when Father McGivney passed away from pneumonia in August 1890. He was just 38 years old.

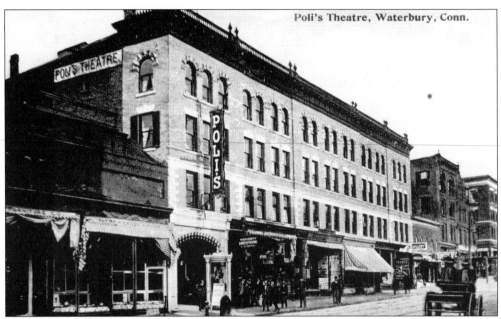

Sylvester Z. Poli, a successful New Haven vaudeville theater owner, decided to expand into Waterbury shortly before the turn of the century. Poli upstaged Eugene Jacques by constructing a theater on East Main Street with one of the largest stages in the country and seating for 1,200. For opening day, December 15, 1897, Francis Wilson was presented in *Half a King*.

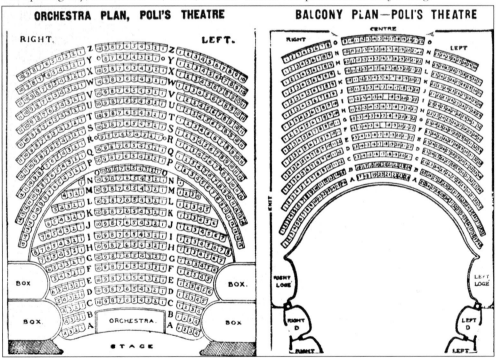

This period seating chart shows how Sylvester Poli improved upon Jacques in every way, including the size of the stage, the number of seats, and the number of boxes. Perhaps most importantly, the Poli Theater had a better location with an entrance right on East Main Street.

This 1917 advertisement shows that despite the proliferation of movie theaters around Waterbury, money could still be made with coin-in-the-slot kinetoscopes and Mutoscopes. These popular peep-show moving-picture machines typically featured short silent films of provocative dancers or humorous slapstick at a bargain price.

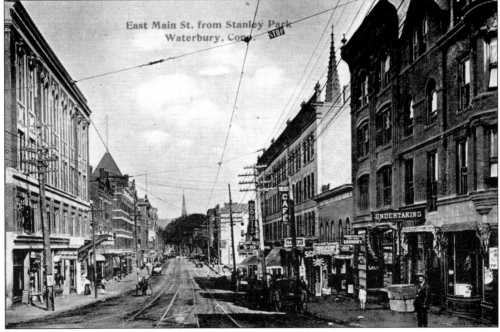

This view is of East Main Street and looks back toward the green. Poli's Theater is seen just right of the center, with the steeple of the Church of the Immaculate Conception rising above. The area across the street soon changed dramatically with the construction of Sylvester Poli's magnificent Palace Theater. The undertaker in the right foreground appears to be having a sidewalk sale, with a stack of pine boxes at the ready.

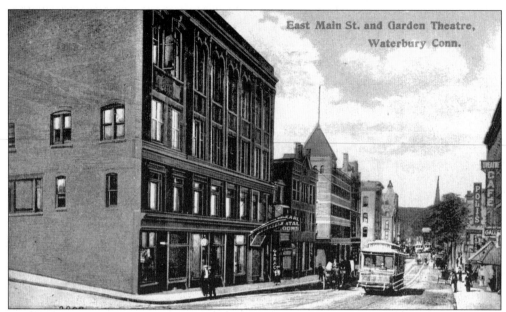

This building on the corner of East Main and School Streets contained both a dance hall, on the fourth floor, and yet another theater, the Garden Theater, indicated by its diminutive sloping marquee. The Garden Theater eventually became a movie theater, the Plaza. The Poli Theater across the street became known as the State.

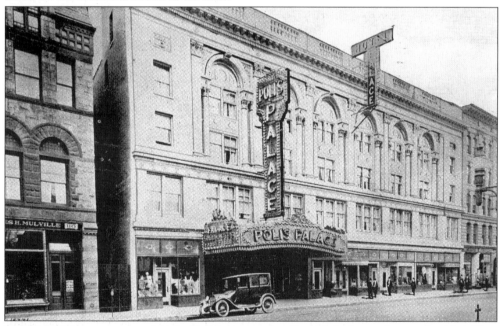

Sylvester Poli soon outclassed himself with yet another East Main Street theater, the $1 million Palace Theater. Thomas W. Lamb, architect of many legendary movie palaces of the period, was awarded the design. The Palace was the flagship theater of the Loews-Poli chain, after Sylvester Poli merged with Marcus Loew's theater chain. With more than 3,000 seats, the Palace was one of the largest theaters in the northeastern United States. The George M. Cohan musical *Mary, Mary* premiered at the 1922 opening.

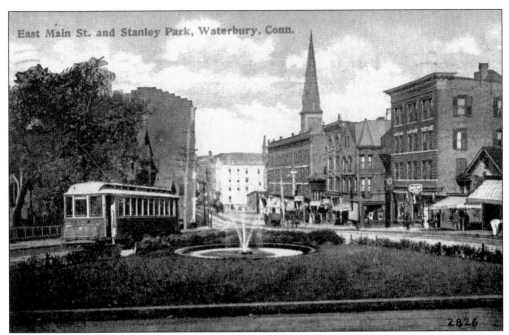

East Main St. and Stanley Park, Waterbury, Conn.

At the intersection of East Main and Cole Streets was this small triangle of landscaping called Stanley Park. In 1906, the city of Waterbury established a tax for park improvements. Consequently, Stanley Park received a sprucing up, the result of which is seen in this postcard. A trolley coming down Cole Street is about to head toward the green via East Main Street.

Croft School was built on the site of the old Elm Street School and behind the site of the original high school on School Street. Named after Margaret Croft, a teacher in Waterbury who retired in 1909 after 46 years, the school contained 17 classrooms and a kindergarten. The school opened in 1905 and featured six-foot-high wainscoted walls of glazed brick in classrooms and corridors. It was damaged by fire in 1914, but was repaired.

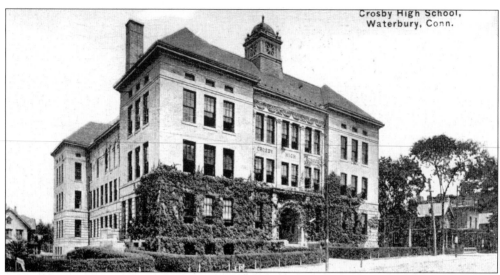

This card stated on the reverse, "Crosby High School, established in 1870 [*sic*], occupies a large attractive building on East Main Street, near Elm Street. The School has a staff of about 20 teachers and an attendance of nearly 500 pupils, and there are 1,000 volumes in its library. The ground, building, and equipments are valued at about $130,000." The school, named after superintendent of schools Minot Sherman Crosby, opened in 1896.

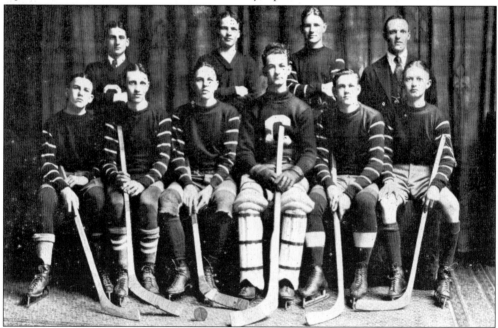

Crosby High School students participated in a wide variety of sports, often with great success; but the 1920 yearbook provided this harsh criticism of the newly formed hockey team, "Though the hockey team was somewhat of a failure, it was far better than was expected from the team that entered into this winter sport for the first time in Crosby's history. The inability to win matches, however, may be attributed to the fact that there were no facilities for practice. Nineteen-twenty men on the team were Burns, Coe, Streeter, Sommers, Thoms, Vanasse. Streeter managed the team besides playing."

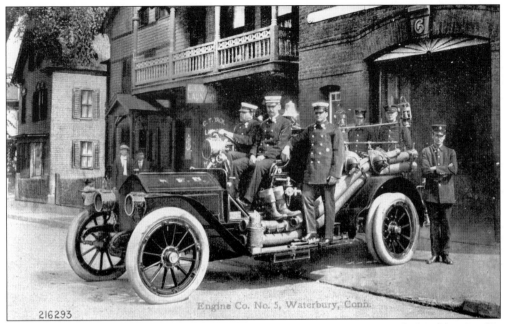

Engine Co. No. 5, Waterbury, Conn.

216293

Proud Waterbury firefighters pose with a shining new American LaFrance triple-combination fire truck at Engine Company No. 5 on East Main Street. This brass-era vehicle from the second decade of the 20th century featured a crank start, a crank siren, acetylene gas headlamps, kerosene tail lamps, and natural white rubber tires. In 1922, Engine Company No. 5 was staffed with 14 men in two shifts. In 1901, this firehouse was known as Engine No. 6, as seen in the keystone.

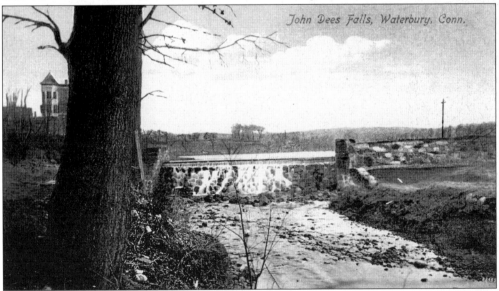

John Dees Falls, Waterbury, Conn.

During most of the 1800s, waterpower was the driving force behind brass production in Waterbury. The Scovill mill utilized water from the Mad River. This dam between the Scovill Mill and East Main Street created a head of water that was directed down an adjacent canal to feed waterwheels that turned the overhead shafts in the machine shops. Alternate sources of power, such as steam, virtually eliminated the need for waterpower, though this dam and the falls remained for decades.

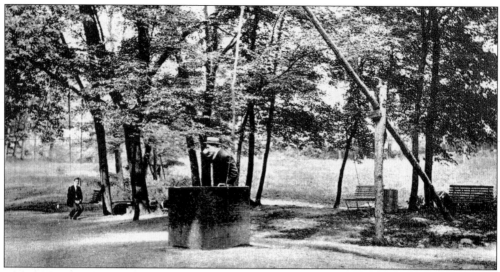

Shortly before the turn of the century, Mrs. David Hamilton donated a parcel of land near East Main Street to the city of Waterbury for creation of a public park in memory of her husband. The development of the park was slow, with improvements occurring only as city funds allowed. This postcard captures a refreshing moment and is sometimes referred to as "the Old Oaken Bucket," in reference to a popular poem written in 1818 by Samuel Woodworth.

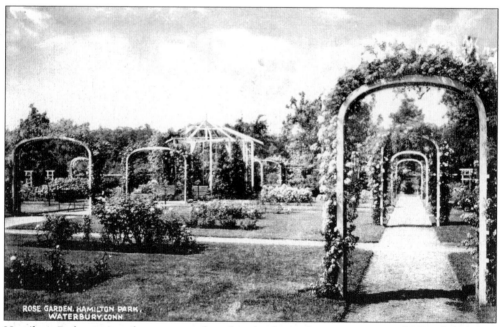

Hamilton Park continued to grow and evolve thanks to the perseverance of Waterbury's city engineer, Robert Cairns, who oversaw much of the original work. After a city tax was levied in 1906 to support park improvements, Hamilton Park enhancements took off in earnest. The city immediately added a variety of plantings and flower beds to the park. Here, the rose gardens of Hamilton Park are shown.

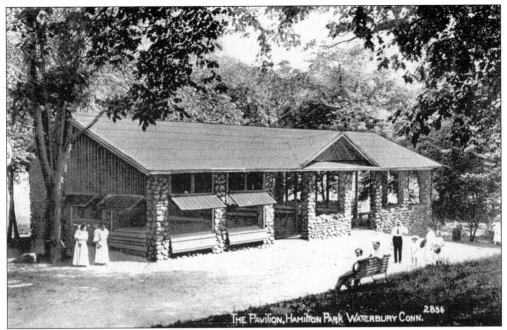

This picnic pavilion has remained a staple in Hamilton Park. Improvements to the park in the early years included a playground with swings and a ball field in 1904, a swimming pool with a pavilion in 1907, and a rustic bridge built over Carrington Brook in 1912. In 1909, a small zoo was built, which, according to Pape, grew to include, "two monkeys, four [raccoons], one possum, one red-tailed hawk, one large owl, one fox, ten grey squirrels and twenty guinea pigs, almost all donations."

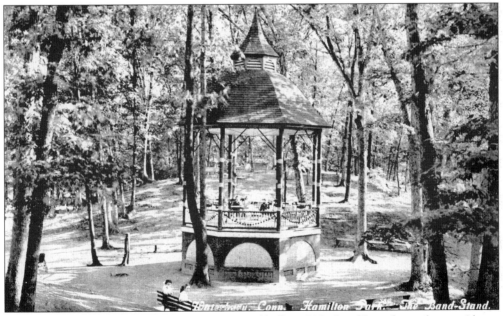

After being banished from the green by Mayor Kilduff in 1902, the old gazebo took up residence here in Hamilton Park. By 1915, the city had acquired a total of 65 acres for Hamilton Park, bounded by East Main Street on one side, and Brass Mill Road and the Mad River on the other.

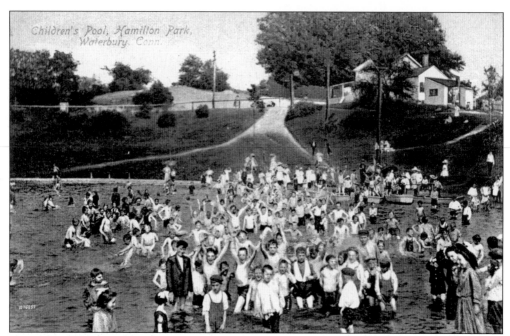

One of the early improvements in Hamilton Park was the creation of a dual-purpose swimming hole and skating pond. Prior to renovations in 1904, this area contained a deep and dangerous mud-filled sinkhole, which had been the site of several accidental childhood deaths. As seen in this view, the improved wading pool was a popular, welcome, and safe addition for children 12 years old and under.

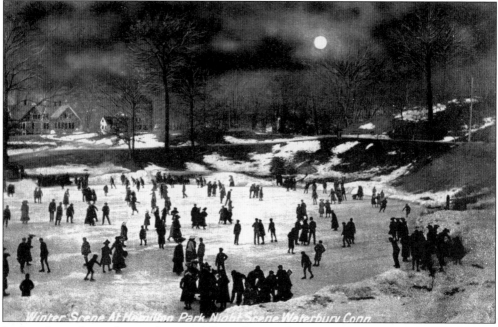

In the winter, the wading pool was transformed into a skating pond as seen in this eerie moonlit view. The Hamilton Park ponds are well documented in postcards, with many scenes available depicting swimmers, couples boating, and decorative fountains.

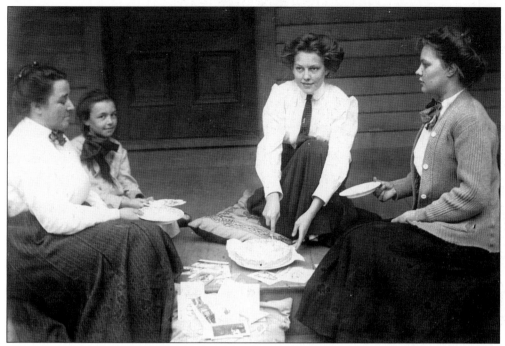

This real-photo postcard records a woman cutting her birthday cake on the front porch of her East Farms home in Waterbury. According to the caption, the woman identified as Mildred Northrup was celebrating her 19th birthday on this day, October 27, 1909. One prominent feature of East Farms at the time was the Maple Hill Dairy, whose cow pastures sat along East Main Street on Pierpont Road.

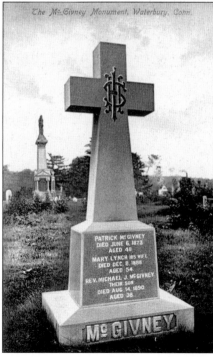

Michael J. McGivney was born in Waterbury on August 12, 1852. After public schooling here, he took a job in a spoon-making department at a local brass mill. At age 16, he decided to enter the priesthood. During Father McGivney's tenure in New Haven, he created a Catholic fraternal benefit society called the Knights of Columbus. Though his remains were later moved to New Haven, this card shows the monument marking his initial resting place at St. Joseph's Cemetery, across the Mad River from Hamilton Park.

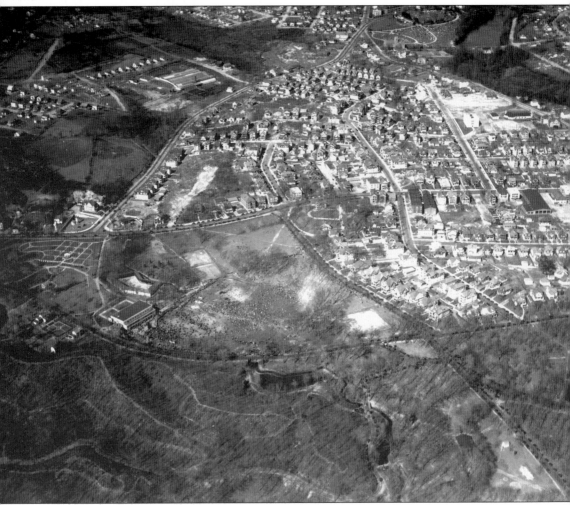

This aerial view of Hamilton Park and East Main Street dates from the 1920s. East Main Street runs horizontally and effectively divides the photograph in half. The Hamilton Park rose garden is seen on the left edge of the photograph. Silver Street would later be redirected through the rose garden to create a four-way intersection with East Main Street and Meriden Road. The swimming pool is seen just right of the rose garden and directly above the dance pavilion. Plank Road swoops below the dance pavilion and heads east toward Prospect. Numerous paths can be seen snaking through the woods. A sharp eye can spot the stone picnic pavilion near the lower right corner, its dark roof hidden amongst the trees. SS. Peter and Paul Church on Southmayd Road is visible in the upper right corner, with its school looking like a white cube, directly behind.

Four

A GRAND TOUR
UNION STATION TO UNION SQUARE

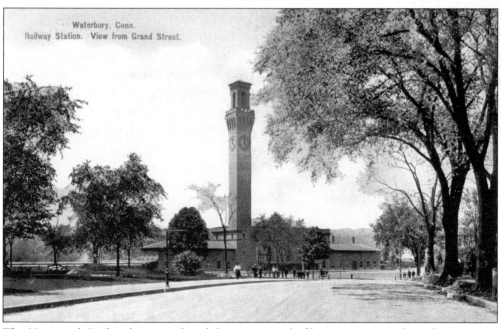

The Naugatuck Railroad was purchased during a period of heavy expansion through acquisition and near foolhardy spending by the J.P. Morgan–controlled New York, New Haven & Hartford. Out of this spending came the grandest of all New York, New Haven & Hartford stations, Union Station in Waterbury. The result, viewed here from Grand Street, was an impressive masonry structure completed in 1908 and topped with a 250-foot clock tower fashioned after the Torra del Mangia in Siena, Italy.

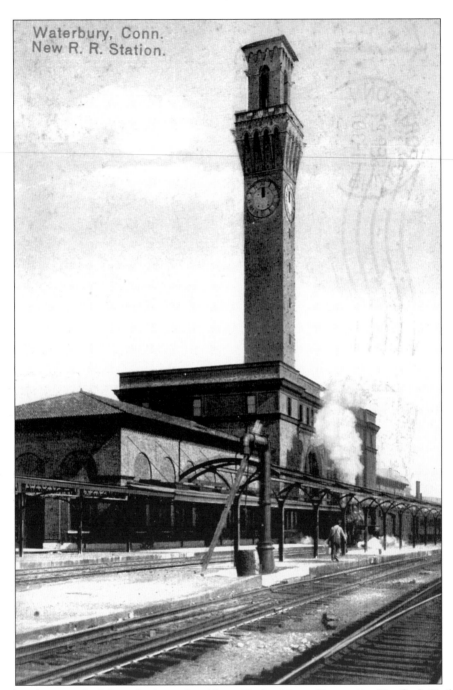

Waterbury, Conn.
New R. R. Station.

For the design of Union Station, the New York, New Haven & Hartford Railroad commissioned renowned architects McKim, Meade & White, who were already well known for their municipal building designs, including the original Pennsylvania Station and Morgan Library in New York City and the public library in Boston. McKim, Meade & White were also no strangers to the Waterbury area, having designed at least six buildings in surrounding Naugatuck and Middlebury, as well as the Buckingham building in Waterbury. In this view of the new railroad station, one important detail is missing—the clock hands.

In 1906, the Naugatuck Railroad officially came under the ownership of the New York, New Haven & Hartford Railroad. Since 1887, the Naugatuck Railroad, which ran from Waterbury to Bridgeport with several short line spurs and connections, had been leased by the New York, New Haven & Hartford for $200,000 a year. The railroad was an important link for Waterbury industries. This card confirms a freight delivery via the railroad.

Form F. 412.

The New York, New Haven and Hartford Railroad Co.

FREIGHT DEPARTMENT.

_____ 190__

The following freight has been received at this station consigned to you from _____ and while on premises of Company will be held at your sole risk of loss and damage.

Unless promptly removed, this Company claims the right to place in public storehouse at the risk and expense of owners, without further notice.

Car No. _____ Initial _____

Transferred from Car No. _____ Initial _____

If carload freight is not unloaded within ninety-six hours, a charge of One Dollar a car, each day or fraction thereof, will be made for detention and use of tracks. Time computed from _____ M. _____

Pro. No. _____ Charges, $ _____

This Company does not undertake to give notice of the arrival of freight. Whenever a notice is sent it is solely for convenience.

Bring this notice with bill of lading when calling for consignment.

Make checks payable to the order of The New York, New Haven and Hartford Railroad Company.

_____ AGENT.

	A.M.	A.M.	A.M.	A.M.	A.M.	P.M.	P.M.	P.M.	P.M.	P.M.	P.M.	A.M.	P.M.	P.M.		
												SUNDAYS				
New Yorklv	441	751	1003	103	200	426	600	600	800	300	525
Stamford..	550	849	1059	1259	228	500	655	720	902	619
South Norwalk.......lv	606	1111	120	247	519	708	743	915	633
Bridgeport...........lv	500	707	918	1140	240	324	601	740	840	1000	435	710
Stratford..............	714	246	607	747	847	1007	442	717
Devon.................	511	718	1148	251	612	752	851	1011	446	721
Derby.............due	526	738	941	1203	310	347	627	811	909	1027	502	738
New Haven..........lv	650	800	1130	550	755	955	705
Derby.............due	826	1157	617	1021	734
Derby.............lv	534	738	826	941	1203	310	347	627	811	909	1027	502	738
Ansonia..............	541	746	833	945	1207	316	352	633	815	915	1031	507	743
Seymour..............	549	755	841	1215	324	641	823	925	1041	516	753
Beacon Falls..........	557	803	849	957	331	830	933	1049	524	802
Naugatuck............	607	812	859	1005	1229	341	657	838	941	1058	533	811
Union City...........	610	815	903	346	841	944	1101	536	815
Waterbury.........due	620	824	915	1015	1244	355	419	708	851	954	1111	545	825
Waterbury.........lv	630	830	1025	1244	433	714	1129	835
Waterville...........	636	836	1032	1250	440	1127	841
Thomaston...........	649	850	1046	103	454	732	1141	855
East Litchfield........	709	908	1103	512	749	1201	916
Torrington...........	722	919	1113	125	523	758	1209	925
Winsted.........due	742	937	1132	145	542	818	1228	945

NEW YORK, BRIDGEPORT AND NEW HAVEN TO WINSTED — WEEK DAYS — SUNDAYS

In 1849, the railroad arrived in Waterbury. The importance of this event to the development of Waterbury industries cannot be overstated. The relative isolation of Waterbury, situated in the rolling hills of western Connecticut, made shipping of heavy metal products challenging. Trucks required teams of horses. The Naugatuck River was not navigable, and the Farmington Canal was only accessible through the notch in Cheshire. The Naugatuck Railroad changed the whole equation.

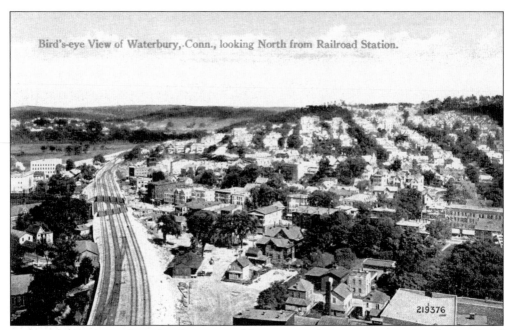

Bird's-eye View of Waterbury, Conn., looking North from Railroad Station.

By 1906, the Naugatuck Railroad was part of the New York, New Haven & Hartford Railroad system and continued north to Watertown and Winsted. But, the New York, New Haven & Hartford did not hold a monopoly on Waterbury industries. This track also carried freight and passengers to Hartford and beyond via the lesser-known New York & New England Railroad. Not far from the station, West Main Street can be seen passing below the track.

POUGHKEEPSIE AND DANBURY TO WILLIMANTIC

Week-Day Trains										Sunday Trains						
			Highland Division													
A.M.	A.M.	A.M.	A.M.	A.M.	A.M.	P.M.	P.M.	P.M.	P.M.	A.M.	A.M.	P.M.	P.M.	P.M.	P.M.	
Poughkeepsielv					905				425						500	
Hopewell Junction					932				458						529	
Brewster					1030				602						626	
Danburydue					1050				623						645	
Danburylv			720		1105				630						653	
Hawleyvillelv			733		1118				652						715	
North Newtown			737		1123				658						721	
Sandy Hook			743		1128				703						726	
Southbury			755		1151				716						739	
Oxford			802		1159				724						747	
Waterburydue			826		1219				752						815	
Waterburylv	600	715	832		1019	1225	423	440	716	802	715	1035	125	335	550	830
East Waterville	606	721	841					446	723	808	721	1041	131	341	556	836
Terryville	620	737	859			1244		501	738	824	737	1059	149	359	614	854
Bristol	630	745	910		1042	1255	446	511	749	835	745	1110	200	410	625	904
Forestville	635	750	915			101		516	754	840	750	1115	205	415	630	909
Plainville	640	755	920			107		521	800	847	755	1120	210	420	635	915
New Britain	650	805	930		1057	119	501	531	811	901	805	1130	220	430	645	926
Hartforddue	710	820	950		1111	140	515	552	831	922	825	1150	240	450	705	947
Hartfordlv		827			1116	200	520	620			827		305		920	
Manchester		849			1132	226	536	647			849		324		939	
Vernon		857			1140	236	544	659			857		332		945	
Andover		918			1200	259	604	723			918		351		1005	
Willimanticdue		935			1214	315	618	740			935		407		1020	
Providence		1152				222	540	818			1150		616			
Putnam		1030				1255	410	659	832		1030		453		1115	
Worcester		1132				150	520	800					750			
Bostondue		1213				230	614	831			1213		650			

The New York & New England Railroad was never a serious threat to the great New York, New Haven & Hartford system. However, this 1917 schedule shows how the New York & New England could deliver Waterbury goods to the Hudson River at Poughkeepsie or to Boston. Notice the time-consuming and roundabout path a passenger traveling to Boston from Waterbury would endure.

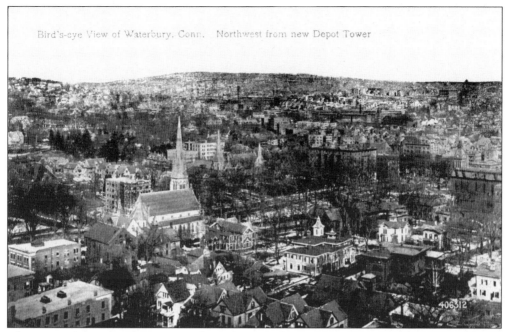

This view of the Waterbury Green from the top of the Union Station clock tower is rich in details. Dominant in the left foreground is St. John's Church. Just to the right is the steeple of the Second Congregational Church. The Hotel Elton is just right of the center, and the old city hall stands on the far right. Since city hall burned in 1912, this photograph must have been taken between 1908 and 1912.

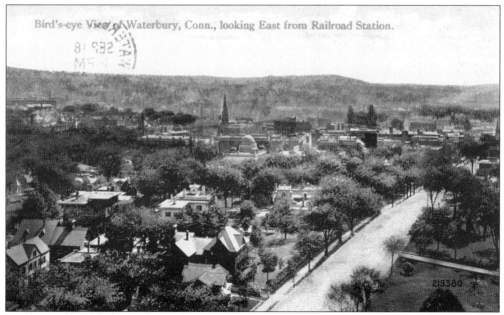

Grand Street appears particularly grand in this view from the Union Station clock tower. The domed building at the center of this photograph is the courthouse. Two structures in silhouette dominate the horizon, the old Church of the Immaculate Conception and its steeple, on East Main Street, and the former Waterbury High School and its two towers.

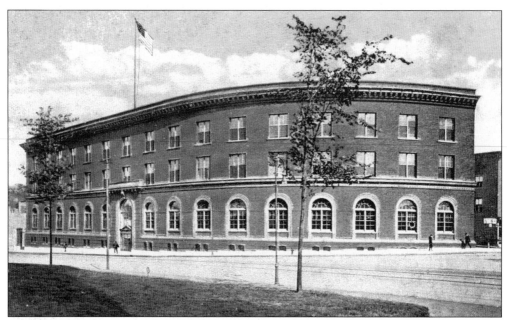

The American Brass Company, which was made up of many of the founding Waterbury brass manufacturers, reorganized in 1912 by consolidating the individual subsidiaries that had operated independently since 1899. In 1913, a new headquarters building was constructed around the curved intersection of Grand and Meadow Streets, across the street from Union Station. The building greeted visitors through an impressive and appropriately brass-clad entryway. (CTPA.)

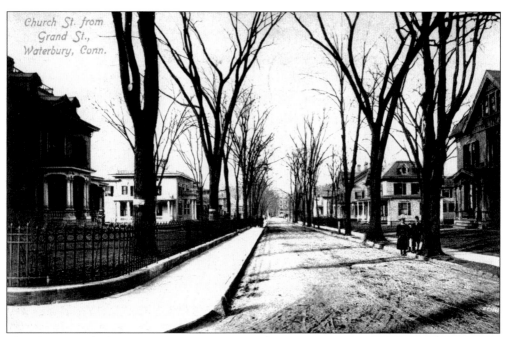

Church Street, which connects Grand Street to West Main Street at St. John's Church, became one of the first upscale neighborhoods in Waterbury. In this view north from Grand Street, the left card edge shows the fenced-in home of John P. Elton, mayor of Waterbury from 1904 to 1906.

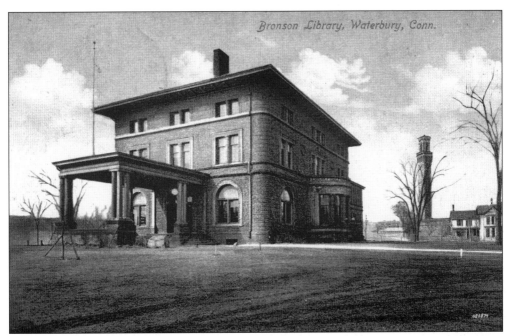

This incarnation of the Silas Bronson Library was built in 1894 on Grand Street. The library and accompanying park were built on the site of Waterbury's oldest burying ground, the graves having been relocated in 1891. As is often pointed out, many of the original headstones were incorporated into the wall surrounding Library Park.

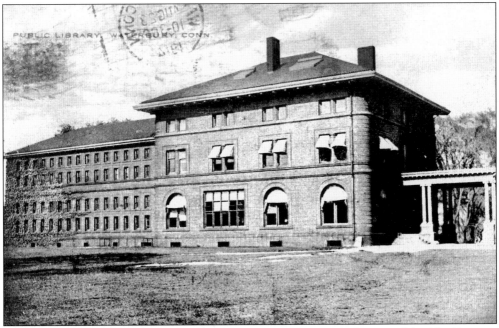

For this postcard, the photographer curiously chose to photograph the rear of the Silas Bronson Library, making this a particularly rare card. Before moving to this site, the Silas Bronson Library was located on West Main Street, next to the old city hall building. The library contained 81,500 volumes in 1910.

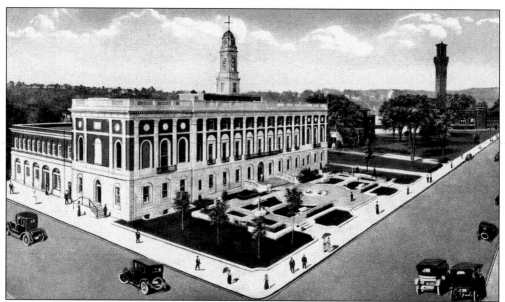

After the original city hall on the green was destroyed by fire in 1912, a new one was built on Grand Street. Cass Gilbert, a protégé of McKim, Meade & White, was selected as the architect of the new city hall, which was completed in 1915. Ten bas-relief medallions adorn the front and sides of the building depicting truth, prudence, industry, the city seal, commerce, force, law, justice, wisdom, and order. Gilbert later used much more symbolism in his design of the Treasury Building in Washington, D.C.

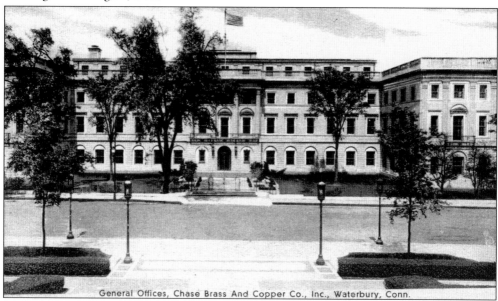

General Offices, Chase Brass And Copper Co., Inc., Waterbury, Conn.

By the second decade of the 20th century, Chase Brass & Copper had joined the ranks of major brass producers in the United States and as one of the "Big Three" of Waterbury. Befitting its stature, Chase constructed a new headquarters building on Grand Street in 1919. Cass Gilbert, whose city hall design sat directly across the street, was selected as architect. Gilbert gained prominence six years earlier as a pioneer in skyscraper design with his execution of the world's tallest building, the Woolworth Building in New York City.

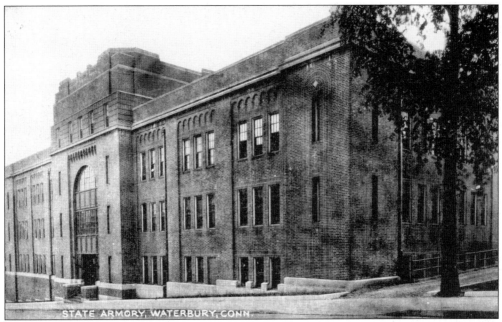

STATE ARMORY, WATERBURY, CONN.

In 1922, a new Connecticut National Guard armory was built in Waterbury, behind city hall on Field Street. This building replaced the earlier armory on the corner of Phoenix and Abbott Avenues. In addition to its official duties, the armory's large open floor space was also used for public events, such as home shows and indoor sporting events. The armory also provided a caretaker penthouse apartment and basement rifle practice ranges.

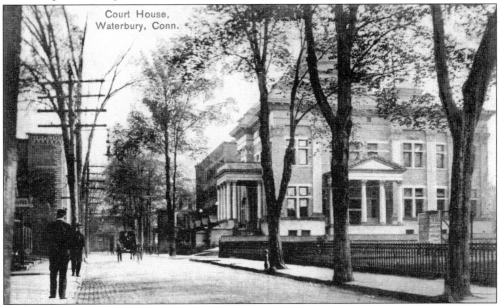

Court House, Waterbury, Conn.

The courthouse on the corner of Kendrick and Leavenworth Streets was built in 1905. Like many of the other Waterbury designs by Wilfred Griggs, this building is of Renaissance Revival style. The courthouse was topped with an impressive dome, which is mostly obstructed by trees in this view. Later renovations to the building drastically altered the exterior, including the removal of the dome.

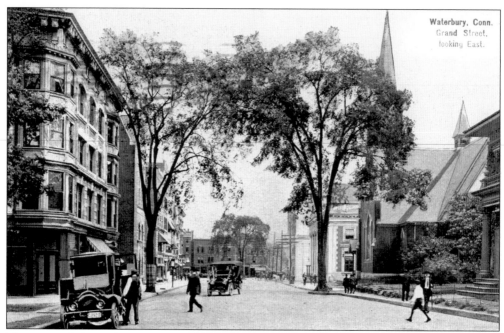

There is perhaps no better way to tour Grand Street than by vintage touring car. In this view looking east from the corner of Leavenworth Street, the *Waterbury American* building, on the left, is partially obscured by tree limbs, and the First Baptist Church and post office are on the right. Grand Street continues by jogging to the right around the distant buildings. After crossing South Main Street, the road becomes Union Street.

The Baptists were early arrivals to Waterbury, dating from *c.* 1803. The First Baptist Church, shown in this view, was built on Grand Street at a cost of $58,000 and was dedicated in 1883. As early as 1904, discussions were underway to enlarge this church to accommodate the growing parish. Though this building survived the great fire of 1902, it succumbed to fire in 1912. The new First Baptist Church was built on the corner of Grove Street and Central Avenue.

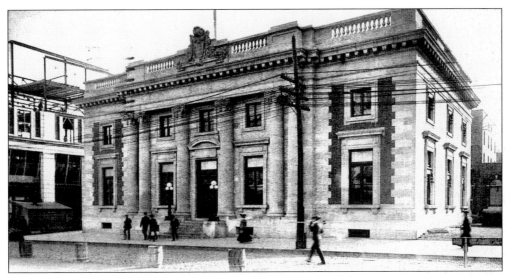

The post office on Grand Street was built in 1904, retiring a storefront post office formerly located behind Apothecaries Hall, on the block between Bank and South Main Streets. In this *c.* 1906 photograph, the Buckingham building next door is under construction. After a relatively short life, this building was razed to make way for an enlarged post office in the early 1930s that remains to this day.

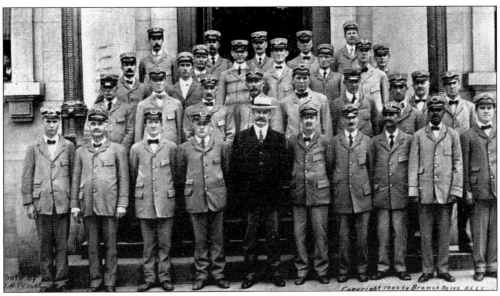

On October 1, 1884, when the carrier system of mail went into effect in Waterbury, five deliverers were hired. The staff of the post office had grown considerably by 1909, when this postcard photograph was taken on the steps of the post office. This picture is credited to the National Association of Letter Carriers (NALC) Branch No. 168. The NALC, established in 1889, is a union of city letter carriers working for the United States Postal Service.

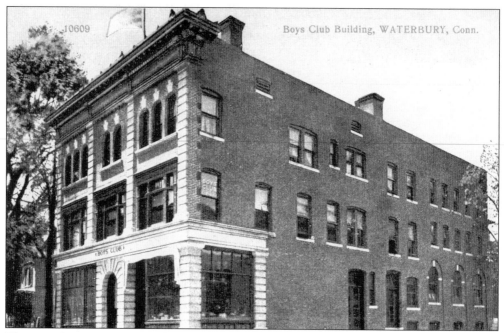

The Waterbury Boys Club, organized in 1888, was originally a home for destitute and neglected boys. From 1905 until 1965, the club resided in this building on Cottage Place behind the post office. The Boys & Girls Clubs of America was a Connecticut innovation that started in Hartford in 1860.

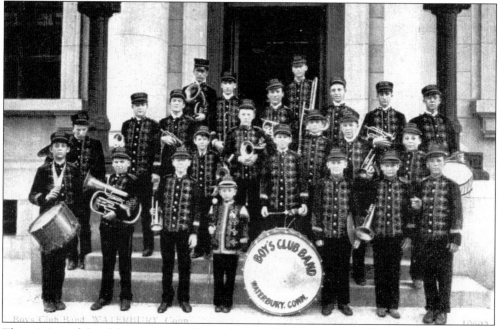

The mission of the club was to provide a safe place for boys who would otherwise be roaming the streets. One of the many programs offered to boys at the Waterbury Boys Club was the Boys Club Band, seen here on the steps of the post office.

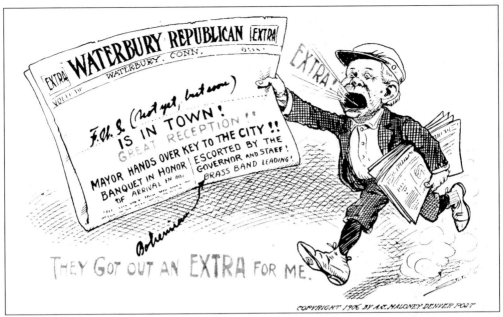

Waterbury boasted three major newspapers in the early part of the 20th century: the *Waterbury Republican*, the *Waterbury Democrat*, and the *Waterbury American*. For a time, all three newspapers were based on Grand Street. This eye-catching novelty postcard also provided a bit of self-promotion for the newspaper. Prior to March 1, 1907, the reverse side of a postcard could contain only the destination address. All correspondence had to be squeezed into blank spots on the front side of the card.

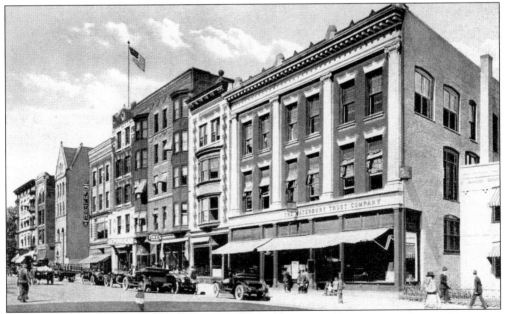

The *Waterbury Republican* newspaper building, with a flagpole, is seen in this view of the north side of Grand Street near Bank Street. Farther away, the *Waterbury American* newspaper building is seen with a sharply peaked roof. The *Waterbury American* building was salvaged from near total destruction by the fire of 1902, when only the façade remained standing. (CTPA.)

In 1906, the *Architectural Record* stated, "Naugatuck and its vicinity contains probably a larger number of buildings designed by McKim, Meade & White than any place in the country, with the unimportant exception of New York." Waterbury was graced with two: the landmark New York, New Haven & Hartford Railroad station, and this, the Buckingham building on the corner of Grand and Bank Streets.

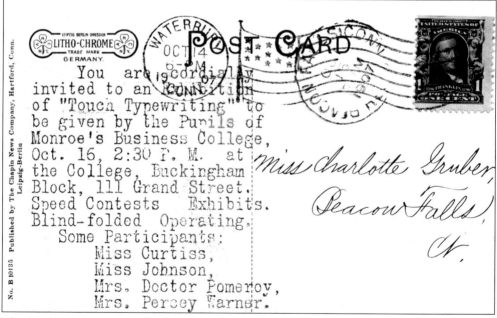

The Buckingham contained room for stores, offices, and, upstairs, a music hall with seating capacity for 1,400 people. One of the businesses in the Buckingham was Monroe's Business College. This 1907 card invited one of the author's grandmothers to a touch-typing exhibition. The card was, of course, typed. (BLH.)

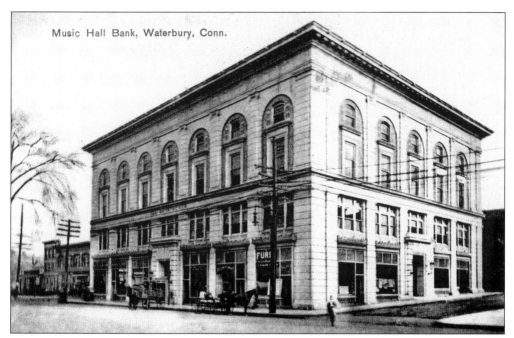

Music Hall Bank, Waterbury, Conn.

As a means to provide financial support for construction of a new Waterbury Hospital, J.H. Whittemore, cofounder of the Naugatuck Malleable Iron Company, chose to erect an office building in downtown Waterbury and donate it to the hospital. The Buckingham building was the result of his generosity. As he had done with his other buildings in Naugatuck and Middlebury, Whittemore selected architects McKim, Meade & White for the Buckingham design.

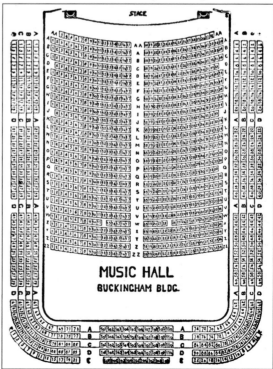

When the Buckingham opened on October 2, 1906, among the artists that appeared at the opening were Louise Homer and Victor Herbert and his orchestra. Louise Homer was from the Metropolitan Opera and was considered the leading American contralto at the time. Victor Herbert was the well-known cellist in the Metropolitan Opera who, only two years earlier, had organized his own orchestra. The Buckingham Music Hall seating chart is shown here.

Prior to the opening of the Palace Theater on East Main Street, the largest hall in Waterbury was the Auditorium on South Main Street. This 1917 advertisement announces a recent renovation. Five years later, on March 13, 1922, Enrico Caruso, the famed Metropolitan Opera tenor, sang to a capacity audience of 2,300. Braving a snowstorm, Waterbury's opera lovers paid $4 or $6 each to see the performance. Caruso died unexpectedly 17 months later.

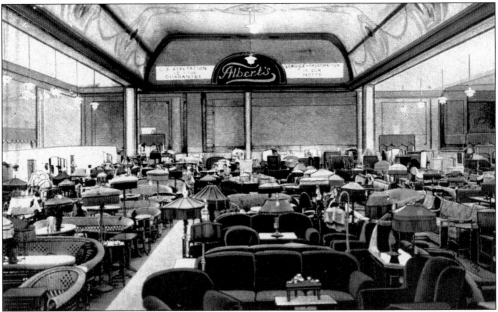

Built in 1891, the Auditorium was the civic center of its day. With a large open floor space, it was used for dances, concerts, conventions, fairs, and even fights. After motion pictures arrived, the Auditorium was frequently utilized as a movie house. As the number of modern movie houses and theaters in Waterbury increased, however, the Auditorium became obsolete. Eventually, it became home to Albert's Furniture, making this perhaps the only furniture store that could proclaim, "Caruso sang here!"

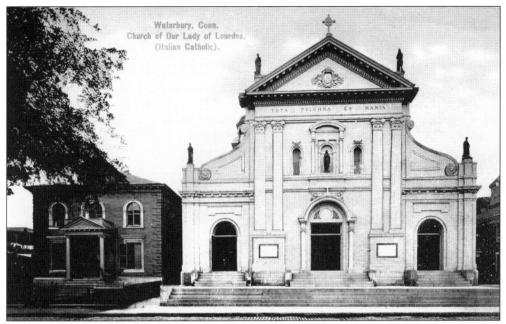

In 1899, the Church of Our Lady of Lourdes parish was created as an offshoot of the Church of the Immaculate Conception to cater to the growing number of local Italian-American Catholics. This building, dedicated in 1909, was constructed in classic Roman style copied from the church of Santa Francesca Romana in the forum of Rome, which dates from *c.* 760 and was built by Pope Paul I.

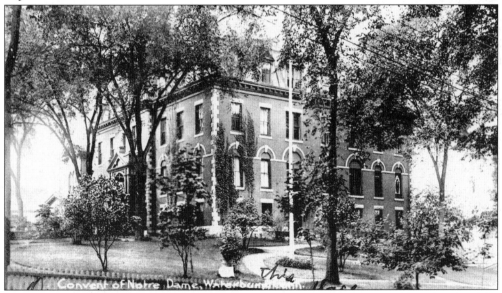

The Convent of Notre Dame was established in 1869 under the auspices of the Church of the Immaculate Conception as a school for young ladies. It was a branch of Villa-Maria Convent in Montreal, Canada. Father Hendricken was the first of a series of pastors at Immaculate Conception who helped enrich Waterbury through the establishment of schools, convents, and hospitals. This building dates from 1892. Later, Waterbury Catholic High School and Sacred Heart High School used this building.

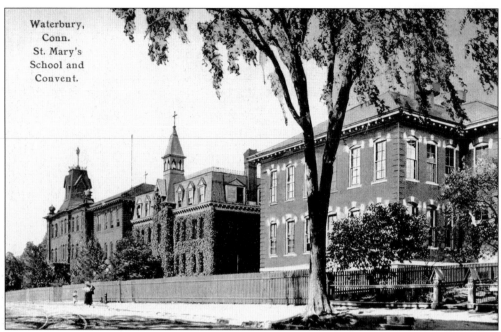

Waterbury, Conn. St. Mary's School and Convent.

This view of the St. Mary's School complex on Cole Street features four buildings: St. Mary's Parochial School, which occupies the buildings on both ends; the Mulcahy building, second from the left; and St. Mary's Convent, third from the left. St. Mary's School was started in September 1888 and run by the Sisters of Charity. The convent was built in 1889. In 1901, the Mulcahy building was added. It contained a library and gymnasium.

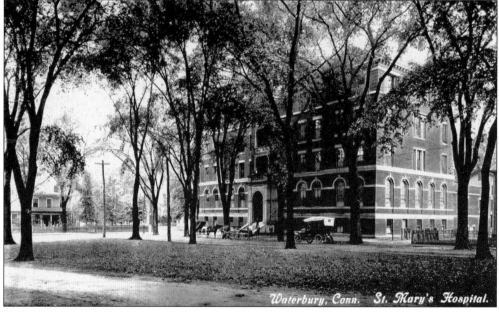

Waterbury, Conn. St. Mary's Hospital.

St. Mary's Hospital, founded in 1907 by the Sisters of St. Joseph, opened its doors to patients in 1909. Rt. Rev. Msgr. William J. Slocum of the Church of the Immaculate Conception provided the impetus for a new hospital as well as initial funding of $20,000. The hospital, shown here, was completed at a cost of nearly $250,000.

84

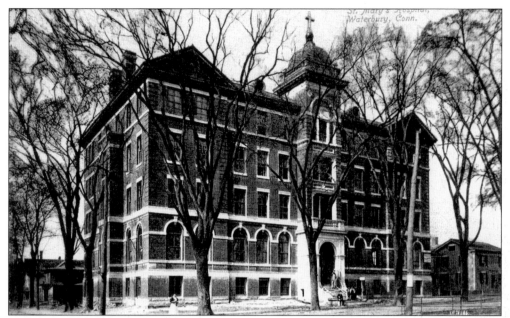

In 1907, the *Souvenir Book of the Charity Bazar* for the new St. Mary's Hospital announced, "The promoters have received the substantial assistance of the businessmen and of the fraternal and patriotic organizations of Waterbury. This is due in no small degree to the fact that the new hospital will be open to men of all classes and creeds. The site of the building is admirably adapted to the purpose to which it is to be devoted. The plans call for a spacious structure with all the latest sanitary appointments."

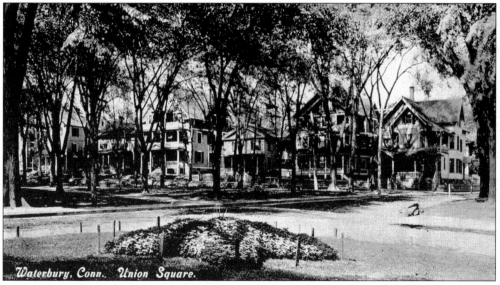

More than 20,000 people gathered here in Union Square in September 1907 to lay the cornerstone for the new hospital. By 1918, St. Mary's Hospital had so outgrown its facility that houses on Franklin Street were purchased to make room for expansion. Opposite the hospital, on the eastern edge of Union Square, was an enormous cluster of brick factory buildings that seemed to stretch for miles. Those buildings belonged to one of the oldest brass mills in Waterbury, the Scovill Manufacturing Company.

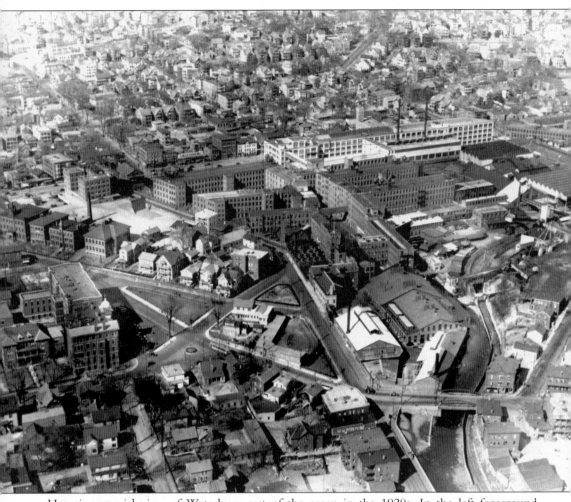

Here is an aerial view of Waterbury east of the green in the 1920s. In the left foreground, St. Mary's Hospital (with a new extension) is seen facing east toward Union Square. North of the hospital is St. Mary's School and Convent. The Scovill headquarters building is seen directly across Union Square from St. Mary's and is recognizable by its light-colored stone work. The enormous Scovill complex extends all the way to the east. A trolley can be seen approaching Union Square from the southeast. Separating the northern edge of the Scovill facility from residential areas is East Main Street, seen traversing left to right. In the foreground, the Mad River disappears beneath some of the Scovill buildings, and the Meriden, Waterbury & Cromwell Railroad follows the river for a bit, before turning easterly. The Scovill complex continued to evolve and grow, nearly doubling its size and extending east, beyond the view of this photograph, until it bordered Hamilton Park.

Five

BRASS MOVEMENTS
INDUSTRIAL AND RESIDENTIAL HUBS

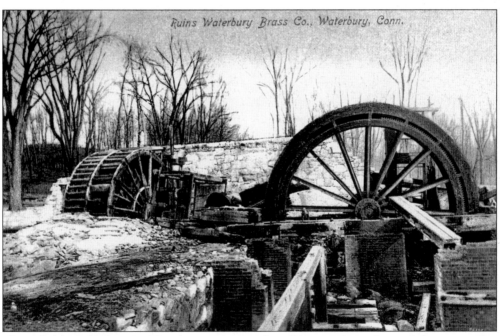

The rolled-brass business in Waterbury grew out of small button shops clustered along a number of local streams, sometimes even sharing space in waterpowered gristmills. The importance of waterpower is evidenced by these huge waterwheels, remnants of the Waterbury Brass Company, which was founded and constructed on the Mad River in 1845. At that time, this East Main Street factory was the largest brass mill in the United States. Eventually, the Waterbury Brass Company became a founding member of American Brass.

One of the pioneers of the brass industry in Waterbury was James M.L. Scovill who, in 1811, with Frederick Leavenworth and David Hayden, took over the pewter button business of Able Porter and formed the Scovill Manufacturing Company. By the 1830s, Scovill was producing sheet brass in newly constructed rolling mills. Scovill Manufacturing expanded along the Mad River near East Main Street, eventually stretching all the way from Union Square to Hamilton Park. (TXPO.)

Abel Porter's button shop seemed a distant memory by 1907, when this advertisement for Scovill boasted a variety of brass products manufactured in Waterbury and featured a number of household items, including buttons. Scovill also pioneered amateur photography in the 1880s by producing cameras and precision plates for daguerreotypes. The Scovill photography unit eventually combined with another camera manufacturer, Anthony & Company, to form Anthony & Scovill, known for decades as ANSCO.

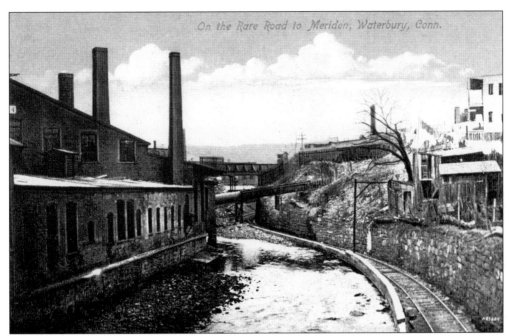

On the Rare Road to Meriden, Waterbury, Conn.

Along the banks of the Mad River were the tracks of the former Meriden, Waterbury & Cromwell Railroad, born out of a concern by Waterbury brass mills that shipping rates charged by the New York, New Haven & Hartford system were too high. After many owners, including the New York & New England Railroad, this line eventually became part of the New York, New Haven & Hartford system anyway. In this view from Scovill's Bridge on Baldwin Street, the track snakes east past the Scovill complex on route to Prospect.

A 1917 schedule for the Waterbury to Meriden service is shown here. The railroad essentially followed Plank Road through eastern Waterbury and northern Prospect before descending into Cheshire near the notch. In Cheshire, this line crossed the New Haven & Northampton Railroad, or "the Canal Line," then continued on to Meriden.

WATERBURY AND MERIDEN

A.M.	P.M.	P.M.		A.M.	P.M.	
....	822	Ar. Waterbury Dublin St. Lv	510	f Stops at Signal
....	315East Farms f.........	518	
....	3:9Summit f..........	5.2	
....	802Prospect f...........	520	
....	757 West Cheshire f	533	
....	750 Southington Road f	538	
....	744Cheshire Street f......	543	
....	734Hanover f,.........	553	
....	729 Meriden, W. Main St.	556	

WATERBURY AND WATERTOWN

	A.M.	A.M	A.M.	P.M.	P.M.	P.M.
Waterbury................	337	510	617
Oakville	345	520	625
Watertown Due	352	533	632

WATERTOWN TO WATERBURY

		A.M	A.M		P.M
Watertown Lv	610	730	742	
Oakville	617	727	549	
Waterbury................	626	738	600	

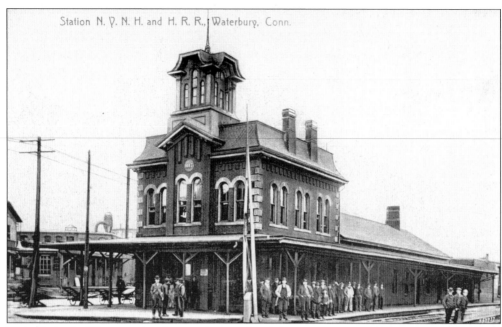

This quaint building on Meadow Street, north of the intersection with Bank Street, was the Waterbury railroad station from 1867 until construction of the more familiar railroad station with the clock tower. In this area, the main line of the Naugatuck Railroad was later moved slightly west during the elevation of the railroad tracks and construction of the new station in the years prior to 1908. Though this station was removed, many of the tracks remained as sidings for the brass mills located here. (SJH.)

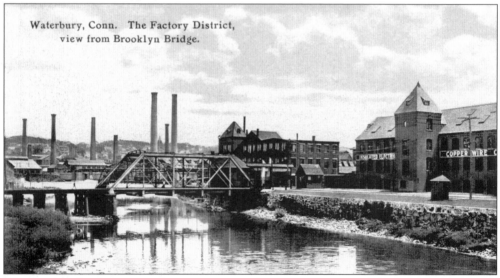

Waterbury, Conn. The Factory District, view from Brooklyn Bridge.

After leaving the downtown shopping area, Bank Street passes several factory complexes then crosses the Naugatuck River into a neighborhood known as Brooklyn. This postcard shows the view southeast from the appropriately named Brooklyn Bridge. On the south side of the river are seen the "wire houses" of the Holmes, Booth & Hayden brass factory. The railroad siding, once part of the original main line, allowed freight to be brought in and out of the local factories and provided employees access between mills.

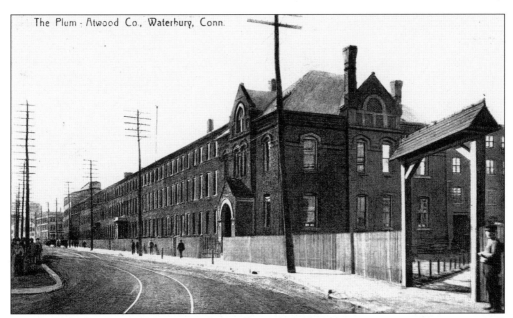

The Plum-Atwood Co., Waterbury, Conn.

By the time of the Civil War, the major players in the Waterbury brass industry were well established and included Scovill, Benedict & Burnham; Holmes, Booth & Hayden; Coe Brass; and Waterbury Brass. In 1871, Lewis Atwood, a foreman at Holmes, Booth & Hayden, started Plume and Atwood, whose rolling mill was built between the Naugatuck River and Bank Street. They became best known for brass lighting products, particularly the familiar kerosene burners that held and adjusted lamp wicks.

THE AMERICAN METAL HOSE Co

Waterbury, Conn., May 7, _____ 191 4

We acknowledge with thanks receipt of your order

No. 7154-C _____ dated 5-4-14 _____

Yours truly,

THE AMERICAN METAL HOSE CO.

The American Metal Hose Company, formerly the Waterbury Brass Goods Company, was incorporated as a division of American Brass in 1908. Though business was slow at first, the operation continued to expand, eventually requiring the addition of a three-story building on Jewelry Street in 1923. American Metal Hose grew to become the leading metal hose manufacturer in the United States.

91

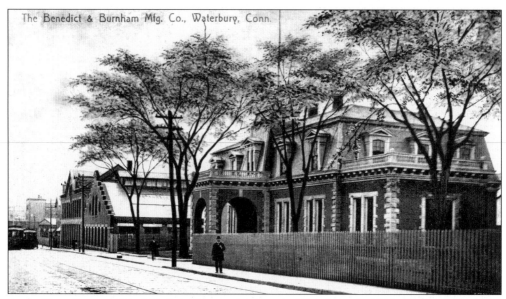

Aaron Benedict established his brass button business in Waterbury in 1812. By 1842, Benedict and his partner, George Burnham, were manufacturing rolled brass at the Benedict & Burnham Company here on South Main Street. They shrewdly and successfully launched companies that would utilize their brass stock, including the Waterbury Button Company, the American Pin Company, the Waterbury Clock Company, and the Waterbury Watch Company.

Organized 1812 Incorporated 1843

Benedict & Burnham Mfg. Co.

BRASS AND COPPER ROLLING AND WIRE MILLS, SEAMLESS BRASS AND COPPER TUBING, BARE AND INSULATED WIRE CABLES.

DEPOTS { 99 John Street, New York
{ 172 High Street, Boston

WATERBURY, CONN.

By the mid-1800s, Waterbury manufacturers dominated the United States brass industry. In 1853, 10 brass manufacturers in Connecticut, including Benedict & Burnham, organized the American Brass Association, which set brass prices and production quotas for its members. Under the growing threat of antitrust legislation, the individual members merged to become the American Brass Company in 1912. The only former American Brass Association member that remained independent was Scovill Manufacturing.

92

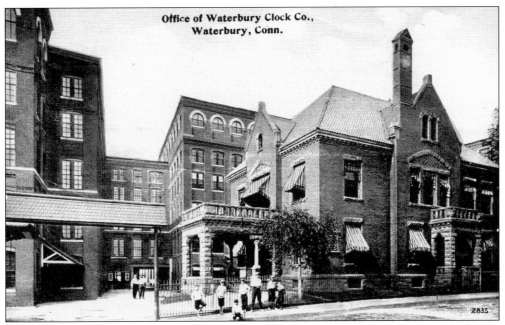

By the mid-1800s, Benedict and Burnham realized that clock manufacturing accounted for a significant portion of their brass production, so they decided to pursue clock making themselves. They first invested in the Jerome family clock-making business before later choosing to create an entirely new clock factory, the Waterbury Clock Company, in 1857. Initially, the Waterbury Clock Company occupied buildings near Benedict & Burnham off South Main Street before moving here, to Clock Avenue, now called Cherry Avenue. (TXPO.)

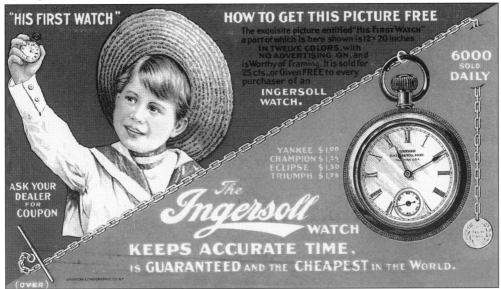

The Waterbury Clock Company built inexpensive clocks in many shapes and sizes, including shelf, mantle, and wall clocks; carriage clocks; tall case clocks; statue clocks; and novelties. But it was the pocket watch, and the company's association with marketing genius Robert Ingersoll, that changed the company forever. Although the above handbill says, "6000 sold daily," at its peak, the Waterbury Clock Company manufactured 13,000 of these watches a day. (TXPO.)

93

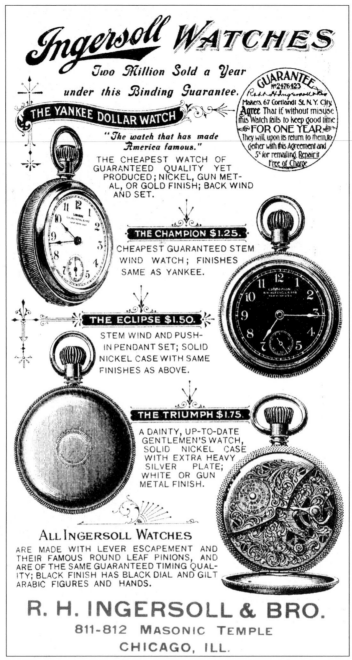

Ingersoll WATCHES

Two Million Sold a Year
under this *Binding Guarantee.*

GUARANTEE
№2476423
R.H. Ingersoll Bro.
Makers. 67 Cortlandt St. N.Y. City
Agree That if without misuse
this Watch fails to keep good time
FOR ONE YEAR.
They will, upon its return to them, to-
gether with this Agreement and
5¢ for remailing, Repair it
Free of Charge.

THE YANKEE DOLLAR WATCH

"The watch that has made America famous."

THE CHEAPEST WATCH OF GUARANTEED QUALITY YET PRODUCED; NICKEL, GUN METAL, OR GOLD FINISH; BACK WIND AND SET.

THE CHAMPION $1.25.

CHEAPEST GUARANTEED STEM WIND WATCH; FINISHES SAME AS YANKEE.

THE ECLIPSE $1.50.

STEM WIND AND PUSH-IN PENDANT SET; SOLID NICKEL CASE WITH SAME FINISHES AS ABOVE.

THE TRIUMPH $1.75.

A DAINTY, UP-TO-DATE GENTLEMEN'S WATCH, SOLID NICKEL CASE WITH EXTRA HEAVY SILVER PLATE; WHITE OR GUN METAL FINISH.

ALL INGERSOLL WATCHES

ARE MADE WITH LEVER ESCAPEMENT AND THEIR FAMOUS ROUND LEAF PINIONS, AND ARE OF THE SAME GUARANTEED TIMING QUALITY; BLACK FINISH HAS BLACK DIAL AND GILT ARABIC FIGURES AND HANDS.

R. H. INGERSOLL & BRO.
811-812 MASONIC TEMPLE
CHICAGO, ILL.

Beginning in 1892, Robert Ingersoll arranged for Waterbury Clock to produce inexpensive watches in great quantity, which he sold as his own. The initial watch, appropriately called "The Jumbo" due to its large size and thickness, sold well, but Robert Ingersoll quickly demanded new models with such features as stem wind and stem set. Most importantly, he wanted a watch that he could sell profitably for the amazingly low price of $1. The Waterbury Clock Company was quick to comply. After all, Ingersoll predicted he could move more than one million "dollar watches" a year. He moved that, and more. So, began the legacy of the Ingersoll watch, "The watch that made the dollar famous!" (TXPO.)

Foremen of The Waterbury Clock Co., 1910.

Although some of the faces are scuffed, this rare and unusual postcard features the department heads of the Waterbury Clock Company in 1910. For the Waterbury Clock Company to specialize in inexpensive clocks and watches, they needed to keep strict control over every stage of manufacturing, which often necessitated elimination of third-party vendors. This photograph provides some insight into the number of departments involved in manufacturing timepieces. (TXPO.)

In 1878, the Waterbury Clock Company moved beside North Elm Street. For the next 40 years, the site underwent almost constant expansion. This view shows the well-developed factory during the time that both traditional clocks and pocket watches were being built here. In the 1920s, Waterbury Clock acquired the assets of another child of Benedict & Burnham, the former Waterbury Watch Company. Eventually, Waterbury Clock became known as U.S. Time and, later, Timex. (TXPO.)

Waterbury Clock Co., Waterbury, Conn.

By the late 1920s, the growing depression had taken its toll on the watch industry and the Waterbury Clock Company found itself in a difficult financial position. But before the end of the decade, the company embarked on a negotiation that turned their fortunes around. In 1929, the Waterbury Clock Company began negotiating an exclusive licensing agreement with Walt Disney Enterprises to place their famous mouse on the face of an Ingersoll watch. The rest is history.

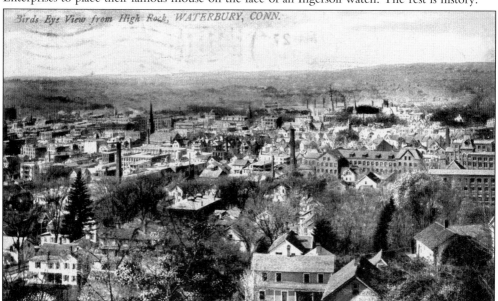

Birds Eye View from High Rock, WATERBURY, CONN.

This postcard shows an easterly view of downtown Waterbury from High Rock. The church steeple to the left of the center is the old Church of the Immaculate Conception on East Main Street, while the green is slightly above the center. The old city hall can be identified, with difficulty, dating this photograph from before 1912. Appearing just along the right edge of this card is the Waterbury Clock Company factory, which is distinguished by its tower and dormer.

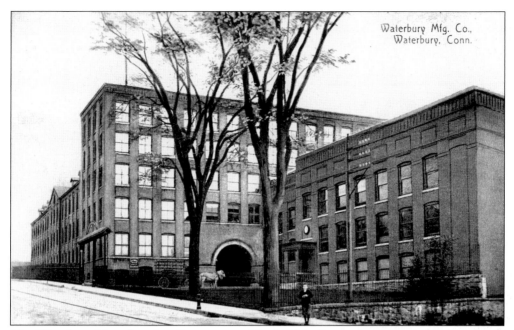

The Waterbury Manufacturing Company on North Main Street, shown here, was founded in 1876 to produce buttons and other miscellaneous brass items. Augustus S. Chase, a Waterbury banker, became the company's first treasurer and eventually president in 1894. Henry Chase took over upon the death of his father, Augustus, in 1896, and created a rolling mill nearby to produce sheet brass stock for his company.

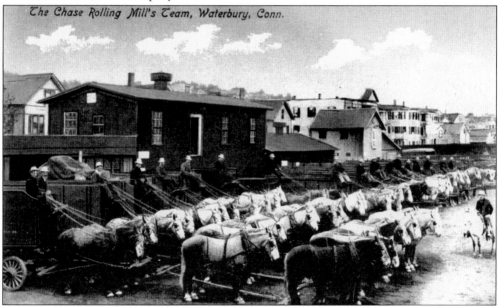

In 1910, Henry Chase decided to move his brass rolling mill operation from North Main Street to an area alongside the Naugatuck River in Waterville. The rolling mill eventually stretched for nearly a mile, placing Chase Metals in a league with American Brass and Scovill Brass, jointly referred to as the "Big Three" brass mills of Waterbury. Chase's rolling mill is fondly remembered for its teams of powerful Percheron draft horses, seen here, used for heavy hauling.

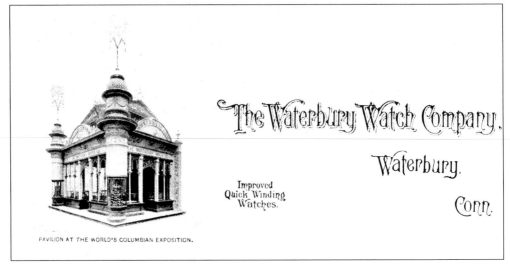

Improved
Quick Winding
Watches.

The Waterbury Watch Company,

Waterbury,

Conn.

PAVILION AT THE WORLD'S COLUMBIAN EXPOSITION.

Just as they had earlier established the Waterbury Clock Company and a variety of other brass-consuming businesses, Benedict & Burnham created the Waterbury Watch Company in 1880. This handbill encourages attendees of the 1893 Columbian Exposition in Chicago to visit the Waterbury Watch Company booth and see "the Century Clock," a clock "twenty-feet high, with more than 100 lifelike moving figures reenacting great scenes of American progress." (TXPO.)

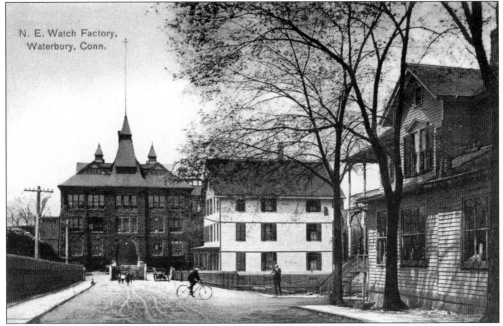

N. E. Watch Factory,
Waterbury, Conn.

The Waterbury watch was inexpensive, reliable, and successful. But the watch required 158 half-turns to wind the 9-foot mainspring each day, hence the nickname "long-wind." The company was located west of South Main Street on Dover Street. In this view, the Waterbury Watch Company main office at the end of Dover Street appears more like a neighborhood schoolhouse, as the factory is hidden behind.

Though the front of this *c.* 1890 trade card shows a generic country scene, the back features this original Waterbury Watch advertisement. At a time when a pocket watch could cost $15 or more, the $3.50 Waterbury watch was a bargain. In yet another testament to the familiarity of the Waterbury brand, in the late 1890s, S.H. Dudley recorded the song "'Twas 27 Bells in the Waterbury Watch" on an Edison cylindrical phonograph record. (TXPO.)

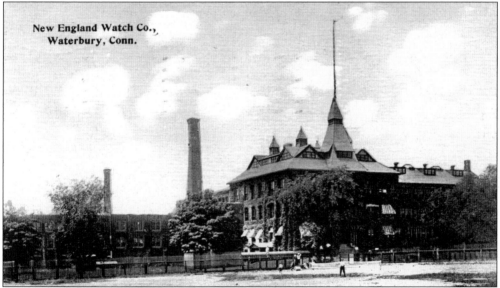

The architecture of the Waterbury Watch Company building possessed a fairy-tale quality as evidenced in this view. The factory had one wing to the right of the headquarters building seen behind the trees, and a second wing that extended back to Benedict Street identified by the distant smokestack. The field in the foreground of this postcard bounded by West Dover, South Main, West Liberty, and Benedict Streets, was used to store woodpiles for operation of the furnaces and generators. (TXPO.)

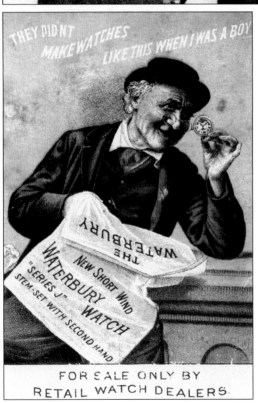

For many years, the name Waterbury was synonymous with timekeeping. In 1893, the Waterbury Watch Company began an extensive advertising campaign, which included these stylish and collectable advertising cards. These cards were sent in lots of 525, free of charge, to any recognized retail watch dealer that requested them. The card backs were left blank for the retailer to use as they wished. Eventually, the Waterbury Watch Company introduced new watch models (such as the "E," "J," and "L" above), solving the notorious "long-wind" problem. The "New Short Wind," "Series J" watch is advertised on the left. (TXPO.)

Factory of the New England Watch Co. Waterbury, Conn.

As the turn of the century approached, the financial position of the Waterbury Watch Company became increasingly precarious. By 1890, the long-wind watch began to lose its appeal with consumers, and the practice by promoters of using the watch as a giveaway gave the Waterbury watch a negative image with both consumers and retail dealers. The Waterbury name itself became such a liability that in 1898 the company reorganized as the New England Watch Company. (TXPO.)

Despite the flurry of new watch model introductions, as seen in this 1907 advertisement, the New England Watch Company continued to slowly edge closer to bankruptcy, closing in 1912. But, like the proverbial white knight, Robert Ingersoll saw an opportunity to expand his watch empire by buying and rejuvenating New England Watch. Success eluded Ingersoll this time, and by the early 1920s, the Ingersoll assets were purchased by the Waterbury Clock Company.

St. Anne's Church, on the corner of South Main and East Clay Streets, was built to cater to the French-speaking Catholics of Waterbury. The church was established in 1886, and the cornerstone for this impressive granite and blue-marble edifice was laid in 1906. Eventually, St. Anne's grew to include two schools, a hall, a rectory, and a convent. The congregation reached 4,000 parishioners by 1917.

During the late 1800s, the rapidly expanding brass mills, with their rapidly expanding workforce, drew thousands of immigrants to Waterbury. One example, Emmerentienne Beauregard (left) was born and raised outside of Montreal, Canada. After marrying Joseph Fregeau, a tailor (not shown), they moved to Connecticut in 1897, eventually settling near East Main Street in Waterbury. Fregeau became a millwright at Scovill, where he remained for 28 years. They raised five children. The children, seen standing with Beauregard, are, from left to right, Lucille, Raymond, Marie-Antoinette, Isabelle, and Phillip. (MDH.)

"This is my home" is the note jotted on this postcard. In addition to commercial postcards, amateur and professional photographs could be turned into postcards, which are referred to today as real-photo postcards. Collectors seek real-photo cards, as they were printed in extremely low quantities, sometimes only one, making them exceedingly rare. This off-center photograph of a home at 57 East Clay Street near St. Anne's Church appears to be more of the amateur variety.

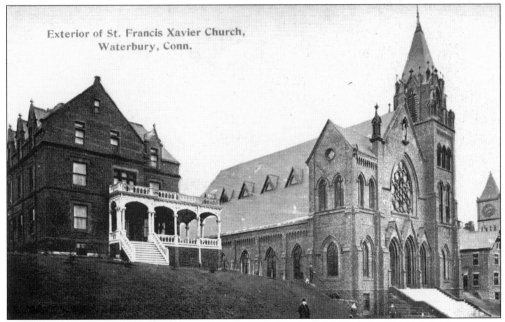

In 1895, St. Francis Xavier Church was established in a temporary building on Baldwin Street to provide convenient access to a Catholic church for 500 families that were previously divided between St. Patrick's, to the west, and Immaculate Conception, to the north. In 1902, the new church with parsonage opened here on the corner of Baldwin and Washington Streets.

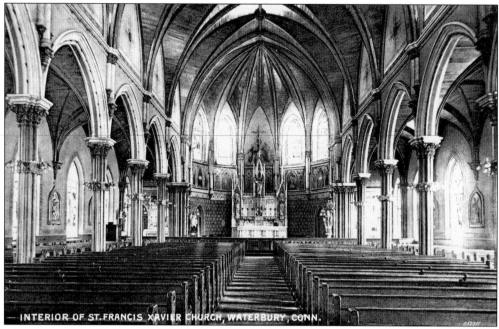

The impressive interior of St. Francis Xavier is revealed on this card. The church is 76 feet wide and 138 feet long with seating for 1,150 people. Rev. Jeremiah Curtin was the founding pastor.

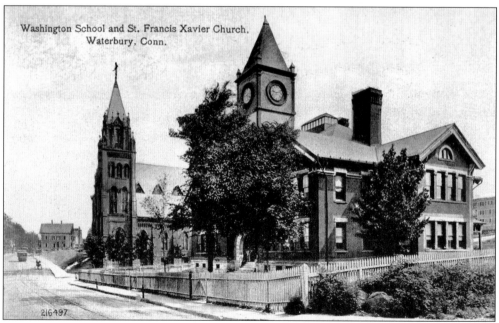

This view looks north up Baldwin Street. In the foreground is Washington School, across Washington Street from St. Francis Xavier Church. The school was built in 1882, and like so many other Waterbury schools at the time, needed frequent expansions. The number of students more than doubled from 262 in 1895 to 585 in 1917, which explains why a four-room addition was constructed in 1894 and an eight-room addition in 1914.

The Bristol Company,

RECORDING INSTRUMENTS

FOR PRESSURE, TEMPERATURE AND ELECTRICITY.

STEEL BELT LACING.

READY TO APPLY FINISHED JOINT

New York Office, 121 Liberty Street.

Waterbury, Conn., U. S. A.,

William H. Bristol founded the Bristol Company in 1889 to manufacture "steel belt lacing," a simple metal staple to repair machine shop leather belting. He quickly moved into industrial instrumentation, particularly recorders for temperature, pressure, humidity, and voltage. Professor Bristol's varied interests resulted in more than 100 patents. In addition to the products depicted on this letterhead, the Bristol Company manufactured pyrometers, a phonograph, a public address speaker system, and a radio set.

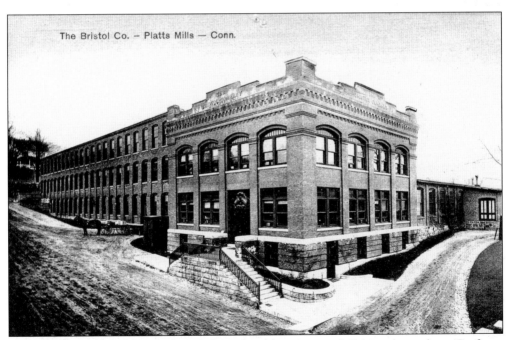

The Bristol Co. – Platts Mills — Conn.

Across the street from his Platts Mills factory on the Naugatuck River, shown here, Professor Bristol later constructed his "million dollar studio" for experimenting on the "Bristolphone," an early talking picture movie projector that predated Vitaphone, the system that became the talking picture standard. In 1926, Professor Bristol added synchronized narration to a series of silent nature films by Dr. Raymond Ditmars, curator of the Bronx Zoo and a noted snakebite venom authority, who visited the Waterbury studio.

WILLIAM H. BRISTOL *presents* "MARY'S LITTLE LAMB"

In 1927, William H. Bristol, president and founder of Waterbury's Bristol Talking Picture Corporation, in cooperation with James Fitzpatrick of Fitzpatrick Pictures in New York City, produced a now-forgotten motion picture for Henry Ford called *Mary's Little Lamb*. The Bristolphone sound system was used to synchronize musical accompaniment and sound effects to enhance an otherwise silent movie. The film was a dramatization of the children's nursery rhyme *Mary Had A Little Lamb* and was created to support Henry Ford's assertion that the Redstone Schoolhouse, then recently moved from Sterling, Massachusetts, to the Wayside Inn site in Sudbury, Massachusetts, was indeed the school immortalized in the rhyme. This rare publicity still taken on location in Sudbury shows actress Anita Louise as Mary, holding the lamb, with Mary's nattily dressed brother Nat sitting across from her. The teacher, Martha Hopkins, and the remaining students actually attended the Redstone Schoolhouse at the time. Anita Louise later starred in numerous Warner Brothers films and eventually in television playing the mom, Nell, in the series *My Friend Flicka*. (MDH.)

Six
ALONG THE NAUGATUCK
WATERVILLE AND POINTS SOUTH

The Naugatuck River appears quite tranquil in this northward view. The trolley tracks on the left have just crossed the river and are seen heading north toward Watertown. Waterbury did not use the Naugatuck River as extensively for waterpower as many of the other Naugatuck Valley mill towns, preferring to use water from the Mad River and Great Brook instead. However, a couple of West Main Street mills did operate from a race. Their water was supplied by a dam on the Naugatuck River north of this spot.

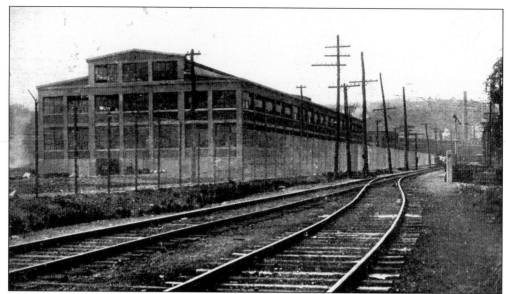

When compared to American Brass and Scovill Manufacturing, Chase Metal Works was a relative newcomer to Waterbury, but president Henry Chase made up for lost time by creating this impressive new rolling mill along the Naugatuck River in Waterville starting in 1910. From 1933 to 1942, Chase also manufactured a specialty line of metalware household items that were distinguished by their art deco styling. These items, stamped with Chase's famous centaur logo, became prized collectors items.

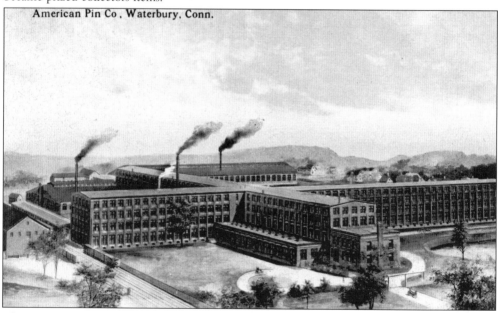

The American Pin Company was yet another successful spin-off by Benedict & Burnham. Created in 1846, American Pin moved from East Main Street to Waterville in 1894. Although pin-making machines were invented in 1832, inserting pins onto cards remained a labor-intensive task until an 1852 invention by Chauncey O. Crosby automated the task. This resulted in the formation of a competitor, the Oakville Pin Company. American Pin later became the Waterville branch of Scovill Manufacturing. (SJH.)

108

Berbecker & Rowland was a brass goods manufacturer located at what would later become the corner of Thomaston Avenue and Huntingdon Avenue. Herbert S. Rowland established the company after purchasing the Tucker Manufacturing Company, a local maker of brass nails. Julius Berbecker became the first president of Berbecker & Rowland, which manufactured cabinet, upholstery, and drapery hardware. The facility later became the Waterbury Corrugated Container Company.

H.L. Welch Hosiery Mill, a knit underwear manufacturer, was started in 1870 and incorporated in 1890 by Henry L. Welch. The knitting machines were powered by water from an on-site millpond filled from Hancock Stream. The factory operated into the second decade of the 20th century, but a downturn in business forced it to close in 1917. Around the corner on Boyden Street, Waterville Cutlery continued a long Waterville tradition of manufacturing knives. This view looks northeast from the corner of Chapel and Main Streets.

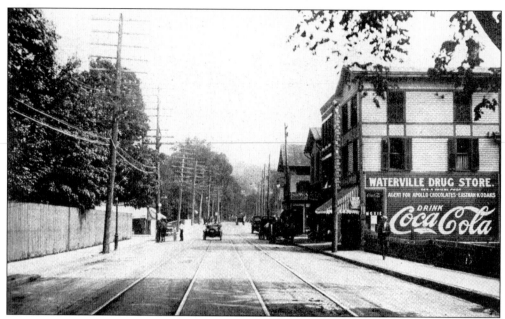

This postcard shows Main Street in Waterville looking south on what was later called Thomaston Avenue. On the left, behind the fence, is the H.L. Welch hosiery mill. On the right, the Waterville Drug Store billboard announces "Agent for Apollo Chocolates and Eastman Kodaks," in addition to the prominent Coca Cola advertisement. Another popular fountain drink, Moxie, is advertised in the window.

This view looks east down Boyden Street from Main Street (Thomaston Avenue). The small wood-frame building in the foreground is the Waterville post office, giving this area the appropriate name Post Office Square. The railroad right of way for the New York & New England line is visible in the background. The New York & New England crosses into Plymouth several miles north of here on route to Bristol, Plainville, New Britain, and Hartford.

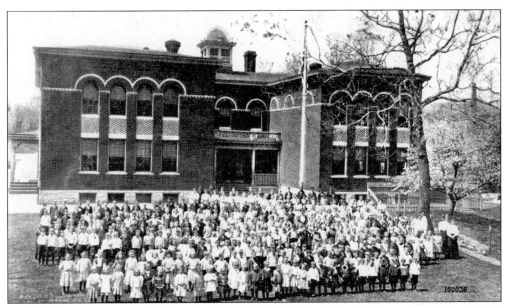

Sprague School was built *c.* 1850 and named after David Sprague, the "father of Waterville." It was originally a two-room schoolhouse, but underwent periodic alterations and additions. By 1905, the school had five classrooms and a kindergarten thanks to a new brick addition. In 1910, three more classrooms were added, as well as a library and recitation room. Gutted by fire in 1912, the rebuilt school opened in 1913 and included innovative fire doors that automatically closed when a fuse melted.

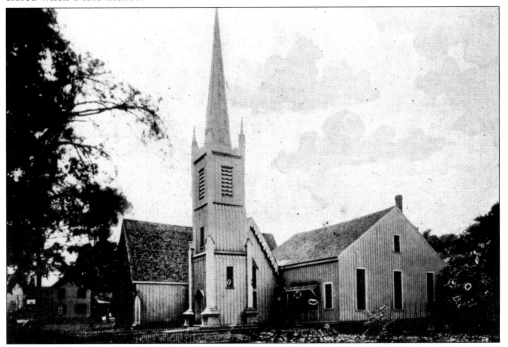

St. Paul's Chapel was established in Waterville as a northern satellite for St. John's Episcopal Church in downtown Waterbury. Located appropriately on Chapel Street, this modest wood-frame chapel with a 70-foot spire was consecrated in 1851. It was illuminated with gas lighting in 1852.

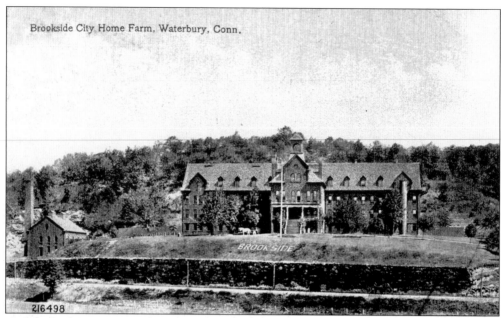

Brookside Home was the city of Waterbury's home for the destitute for close to 75 years. It opened in 1892 along Watertown Avenue and was also an operating farm. The large field in the foreground was later utilized by the city for construction of a new municipal stadium in the 1930s.

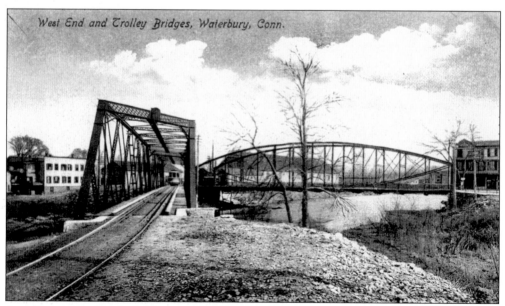

A trolley approaches the bridge over the Naugatuck River en route to Watertown. On the far side, this track joins West Main Street coming over the West End Bridge en route to the green. Prior to elevating the railroad track through Waterbury from 1906 through 1908, both this trolley line and West Main Street crossed the Naugatuck Railroad track at grade level.

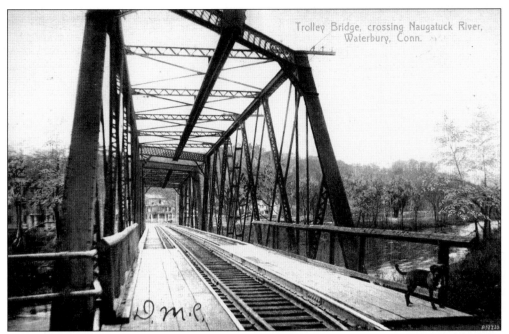

A dog eyes the postcard photographer on the eastern side of the West End trolley bridge. This trolley line carried Waterbury residents to companies like the Oakville Pin Company in Watertown and carried Watertown residents to downtown Waterbury for shopping. The Naugatuck River is seen on the right of this view, which looks north toward Thomaston.

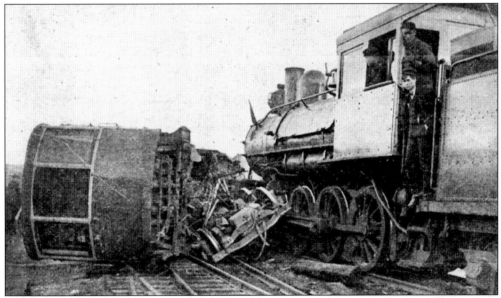

The trolley system in Waterbury was not without incident. In 1903, a trolley strike turned violent resulting in the death of a Waterbury officer who was defending a trolley crew. Four years later, on November 29, 1907, a collision between a double engine freight train and an afternoon trolley returning from Oakville, seen here, resulted in five deaths. A flagman had erroneously raised his gate, which allowed the trolley to cross the New York, New Haven & Hartford Railroad track on West Main Street and into the path of the train. (SJH.)

This calendar for Leavenworth Brothers Dairy on Waverly Street bemoans the dangers of concocting your own bathtub gin in the days of prohibition. Lifting up the cartoon flap reveals the text, "Our natural milk and cream from selected State tested herds provides a food that is as easily digested as Mother's milk and makes happier and stronger babies. Bottled in our own Sanitary Dairy under our own personal supervision, its purity is protected."

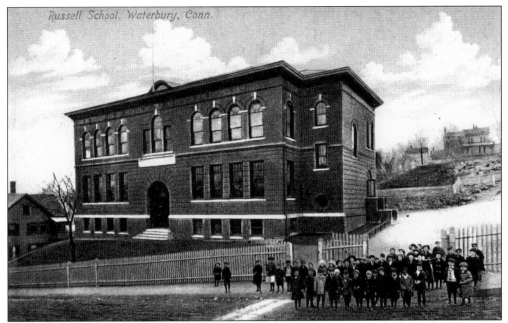

School's out! Or so it seems in this view of Russell School on West Main Street. The school opened in 1901 with six classrooms. From 1896 to 1900, the number of students in Waterbury more than doubled, and the Waterbury school system struggled to keep pace. By 1910, Russell School needed more room, so two additional classrooms and a kindergarten were added. Behind the schoolyard, several homes on Wilson Street can be seen. Attendance here reached 426 students by 1917.

This real-photo postcard is of the home at 1069 West Main Street as it ascends Waterbury's western slopes. In this hilly location, the side porch was clearly designed to take advantage of what is undoubtedly an impressive view of the Naugatuck Valley and downtown. Yet, in these days before pollution controls, when the brass industry in Waterbury was at its zenith, the view almost certainly included a vast array of smokestacks all belching black smoke.

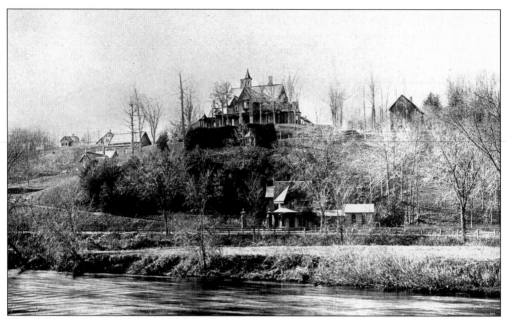

This Victorian home of Allen B. Wilson sat on the western hills of Waterbury with a commanding view of the Naugatuck River and downtown. Wilson is acknowledged as inventor of many enduring improvements to the sewing machine, including the four-motion feed mechanism and the rotary hook and bobbin combination. His company, Wheeler & Wilson, which produced one of the most popular sewing machines, started in Watertown in 1851, but moved to Bridgeport in 1856, before being acquired by Singer.

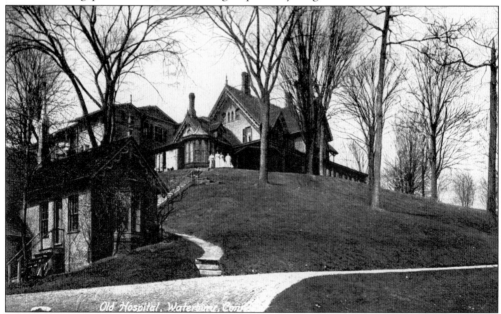

In 1890, the Allen B. Wilson estate was converted into Waterbury's first hospital, shown here. During the first year of operation, the hospital admitted 85 patients and charged $7 per day. In this view, four women, likely nurses, wait at the top of the stairs. The hospital was located south of West Main Street above Riverside Drive.

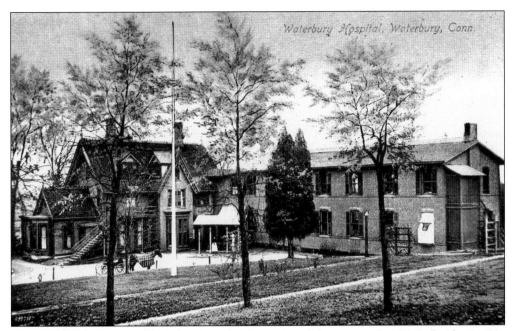

A horse with a carriage waits patiently at a hitching post while a woman is seen under the awning in this unusual backside view of the old Waterbury Hospital. A large brick addition on the right greatly expanded the original Victorian-era home. During the early 1890s, Waterbury Hospital had just two staff doctors with eight visiting physicians and surgeons.

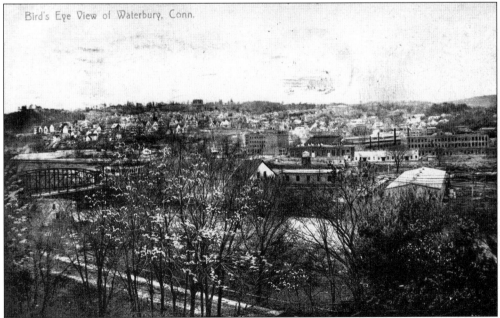

This postcard offers a view of Waterbury from the western hills, probably from the grounds of the old Waterbury Hospital. In the foreground is Riverside Drive. On the left, a bridge takes travelers on West Main Street over the Naugatuck River toward the green. In the distance, the Hillside and Overlook areas appear only sparsely settled. The large buildings opposite the river are trolley car barns used by the Connecticut Company.

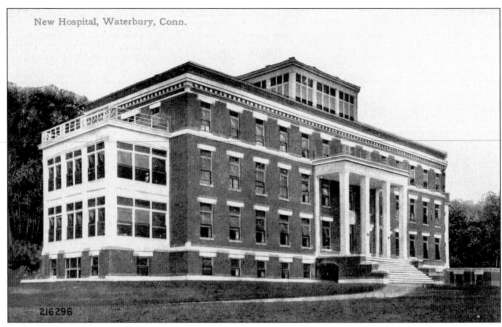

New Hospital, Waterbury, Conn.

216296

Though several additions and out buildings were added to the old Waterbury Hospital, the entire hospital complex was eventually deemed too small and replaced in 1911 by a new Waterbury Hospital, shown here. Henry Bacon was selected as the architect. Bacon, who also designed the railroad station in Naugatuck, and later the Whittemore Memorial Bridge in Naugatuck, rose to national prominence as the architect of the Lincoln Memorial in Washington, D.C.

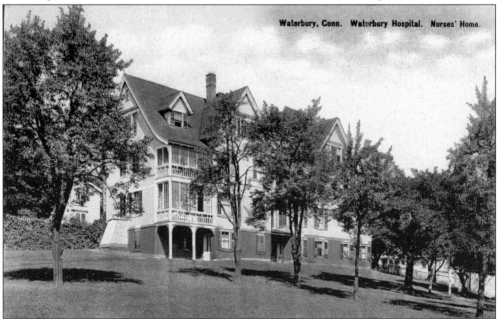

Waterbury, Conn. Waterbury Hospital. Nurses' Home.

In 1892, construction was started on a nurse's home just west of Waterbury Hospital. At that time, the nursing staff consisted of eight women. When Waterbury Hospital moved north of West Main Street to its present location, a 21-acre parcel known as Westwood, the Holmes estate that had originally occupied that site was remodeled into a nurse's dormitory.

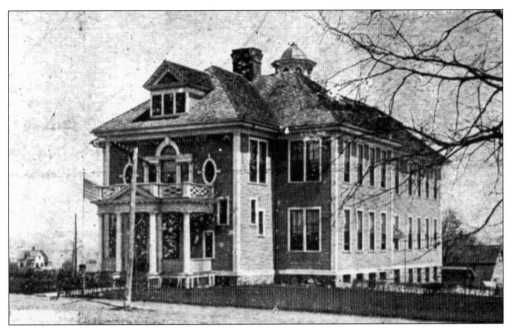

The original eight-room wood-frame Town Plot School, seen here in 1914, was built in 1898 on Highland Avenue. Town Plot was the location of the original local English settlement in 1674. But concern over the growing tensions between settlers and Native Americans that led to King Philip's War convinced the settlers in Town Plot to relocate to the area just west of the Waterbury Green in 1677. Eventually, that settlement became Waterbury and grew to include Town Plot as well.

The Town Plot Class of 1914 is seen on this postcard. It is likely that this is the last class of the independent Town Plot School District because, after a January 1915 vote, the school was brought under the jurisdiction of Waterbury's board of education. By 1917, the Town Plot School attendance was 303 students.

Mrs. Augustus Chase purchased this parcel of land alongside the Naugatuck River in 1905 for the purpose of creating a park in memory of her husband, the president of Chase Copper & Brass. In this view prior to major improvements, Chase Park is still quite rustic. A haphazard arrangement of park benches appears ready to be distributed around the park.

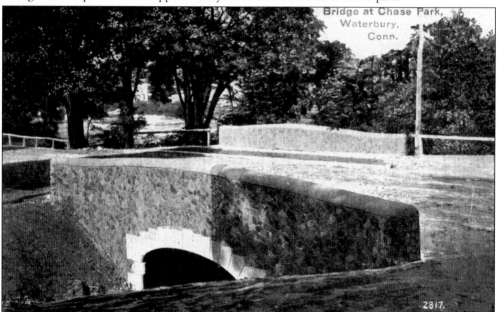

In 1910, a number of improvements were made to Chase Park, including the creation of a new bridge over Sled Haul Brook, a dam, a footbridge, and a variety of paths. In 1930, the signature piece at Chase Park became a granite monument to the Pilgrims carved by Herman Atkins MacNeil, designer of the U.S. Mint's Liberty Standing quarter. Decades later, highway construction forced Chase Park and the Harrub Pilgrim memorial to be relocated up the hill west of the original site.

Hillside Avenue may be where many of the Waterbury industrialists lived, but Riverside Cemetery is where many were laid to rest. In 1884, this chapel was constructed at the entrance of Riverside Cemetery to be used for funeral services. S.W. Hall left behind $20,000 for the purpose of constructing a chapel in 1877 and R.W. Hill was chosen as the designer. The chapel includes a 67-foot tower.

Riverside Cemetery, shown here, was a parklike setting, complete with its own chapel, reflecting ponds, arched bridges, stolid obelisks, and angelic statuary. In fact, the combination of Riverside Cemetery, Chase Park, and the grounds of Waterbury Hospital provided an unbroken stretch of landscaping along Riverside Drive from Bank Street to West Main Street. The cemetery was dedicated on September 24, 1853.

It is hard to imagine that anyone but the most avid golfers would be venturing out to the Waterbury Country Club on a day like this. Yet this card shows the entrance to the country club (in the distance) during one of Waterbury's familiar ice storms. Of interest is the wood-plank sidewalk in what is an otherwise ageless photograph.

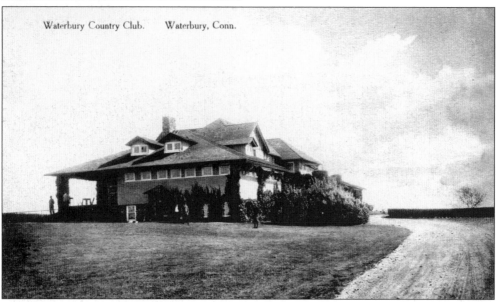

Waterbury Country Club. Waterbury, Conn.

The Waterbury Country Club was formed in 1907, a direct descendant of the Waterbury Golf Association that started in 1898 and is recognized by the United States Golf Association as one of the first 100 clubs established in the United States. The original clubhouse, shown here, was built in 1908 on 183 acres in the western hills of Waterbury. It burned down in 1927 during a major golf course redesign and expansion. The first club president was George L. White, president of the New England Watch Company.

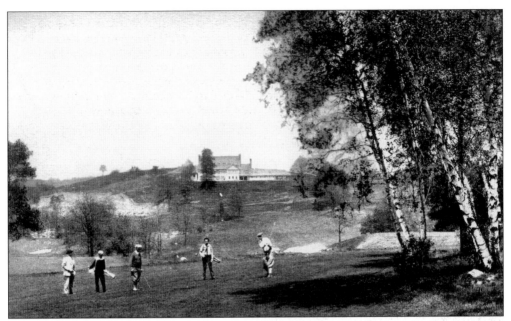

In 1929, the Waterbury Country Club unveiled its new clubhouse, seen in the distance, and a brand new golf course that increased the original 9-hole course to 18-holes. Legendary architect Donald Ross designed the new course. Ross is considered a pioneer in golf-course design. Many of his efforts have remained classic championship courses, including Pinehurst No. 2 in North Carolina, Seminole in Florida, and Oakland Hills outside of Detroit.

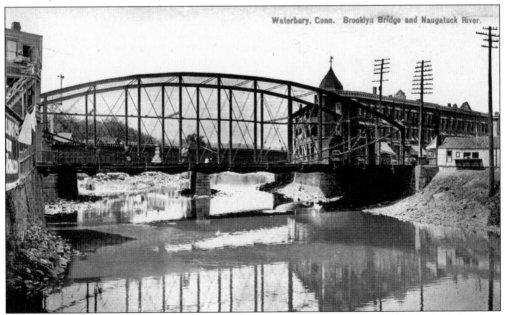

Brooklyn Bridge, as seen from a railroad siding, takes Bank Street travelers from the factory region of Waterbury (right) into the Brooklyn neighborhood (left). The large building on the right was a multi-tenant housing facility known as Wards Flat. On this bend in the Naugatuck River, the main New York, New Haven & Hartford Railroad line is seen, hidden behind the Brooklyn Bridge, also crossing the Naugatuck River.

123

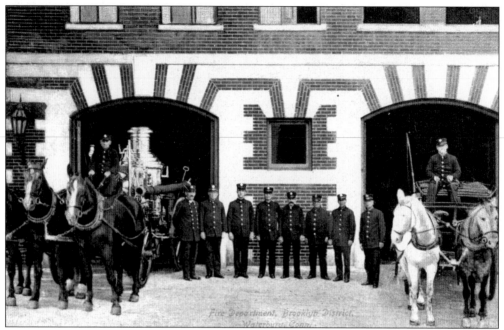

In 1908, the city of Waterbury purchased its first motorized fire engine. Prior to that, only horse-drawn vehicles, such as these at the Brooklyn firehouse, were utilized. The steam pump on the left used forced steam from an upright boiler to drive a water pump, which was a tremendous advantage over hand pumps and earlier methods like bucket brigades. By 1917, the Waterbury Fire Department had grown to 85 paid officers. (SJH.)

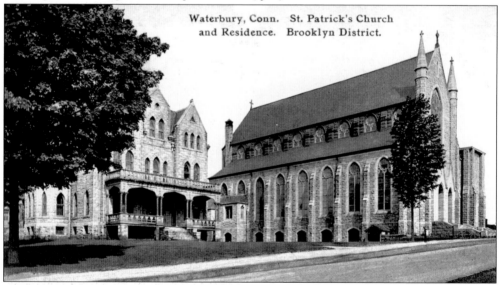

The neo-Gothic St. Patrick's Church in Brooklyn was dedicated on January 18, 1903, a full 22 years after the cornerstone was laid. The original pastor was Rev. John Duggan, who unfortunately never lived to see the structure completed. The church was built in the heart of what was then a predominantly Irish-Catholic neighborhood, which likely influenced the Gaelic inscriptions in the stained-glass windows. The original design included a flat-roofed tower with a spire that was never completed.

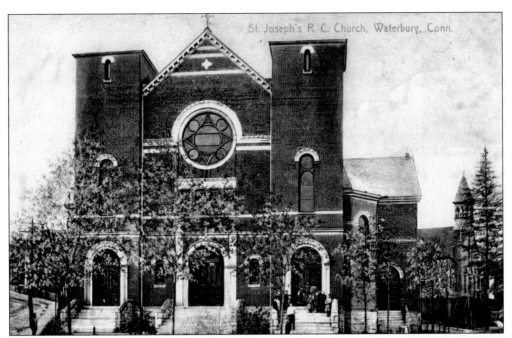

St. Joseph's Roman Catholic Church in the Brooklyn neighborhood was established initially to serve the growing Lithuanian population of Waterbury. With its cornerstone placed on Thanksgiving Day 1894, this 800-seat church on the corner of James and John Streets boasted a membership of 6,000 people by 1917.

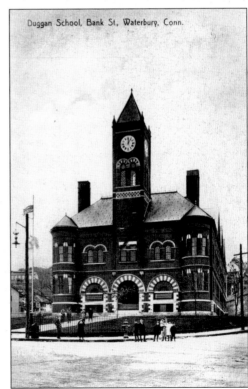

Duggan School in Brooklyn was built in 1890 at a cost of $60,000 and topped with a 90-foot clock tower. Originally known as the Bank Street School, it was later renamed in honor of Rev. John Duggan, first pastor of St. Patrick's. At the opening, it contained twelve rooms for 50 students each, four recitation rooms, and one large room in the basement for 150 evening students.

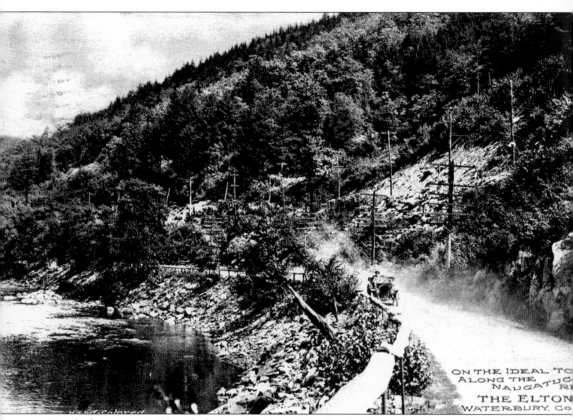

ON THE IDEAL TO
ALONG THE NAUGATUC
NAUGAT RI
THE ELTON
WATERBURY, Co

Hotels that were on "the Ideal Tour," such as Waterbury's Elton, shared a common attribute, roads of a reasonable quality connecting them. This was important in 1905, when the Ideal Tour was created, as automobiles were just entering the scene, and most main thoroughfares were still dirt. Here, an automobile heads south alongside the Naugatuck River on what became state highway Route 8. Judging by the terrain and what appears to be a trolley line on the hillside, this photograph is likely of the stretch between Naugatuck and Beacon Falls.

BIBLIOGRAPHY

Anderson, Joseph. *The Town and City of Waterbury, Connecticut, From the Aboriginal Period to the year Eighteen Hundred and Ninety-Five*. New Haven, Connecticut: the Price & Lee Company, 1896.

Bologna, Sando. *The Italians of Waterbury: Experiences of Immigrants and Their Families*. Portland, Connecticut: the Waverly Printing Company, 1993.

Chesson, Frederick W. *Images of America: Waterbury*. Dover, New Hampshire: Arcadia Publishing, 1996.

Deleo, Michael. *The Waterbury Factbook*. Waterbury: Silas Bronson Library, 1999.

Ly, Tran Duy. *Waterbury Clocks: History, Identification and Price Guide*. Arlington, Virginia: Arlington Books, 1989.

Mattatuck Historical Society. *Waterbury 1674-1974: A Pictorial History*. Chester, Connecticut: Pequot Press, 1974.

Mattatuck Historical Society. *Metal, Minds and Machines*. Waterbury: Mattatuck Historical Society, 1980.

McDermott, Kathleen. *Timex: A Company and Its Community 1854-1998*. Middlebury, Connecticut: Timex Corporation, 1998.

Nelson Company. *Views of Waterbury*. Portland, Maine: L.H. Nelson Company, 1904.

Pape, William J. *Pape's History of Waterbury and the Naugatuck Valley, Connecticut*. Chicago: S.J. Clarke Publishing Company, 1918.

Pearson, Frank T. *Frank T. Pearson's Pocket Guide*. Waterbury: Frank T. Pearson Publishing, February 1917.

Rockey, J.L. *History of New Haven County, CT*. New York: W.W. Preston & Company, 1892.

Roth, Matthew W. *Platt Brothers and Company: Small Business in American Manufacturing*. Hanover: University Press of New England, 1994.

Russell, Rosalind, and Chris Chase. *Life is a Banquet*. New York: Random House, 1977.

Turner, Gregg M. *Connecticut Railroads: an Illustrated History-One Hundred Fifty Years of Railroad History*. Hartford: Connecticut Historical Society, 1989.

United Catholic Societies. *Souvenir Book of the Charity Bazar for the Benefit of the New St. Mary's Hospital-April 13th to 22nd, 1907*. Waterbury: United Catholic Charities, 1907.

INDEX